PAST
TIME

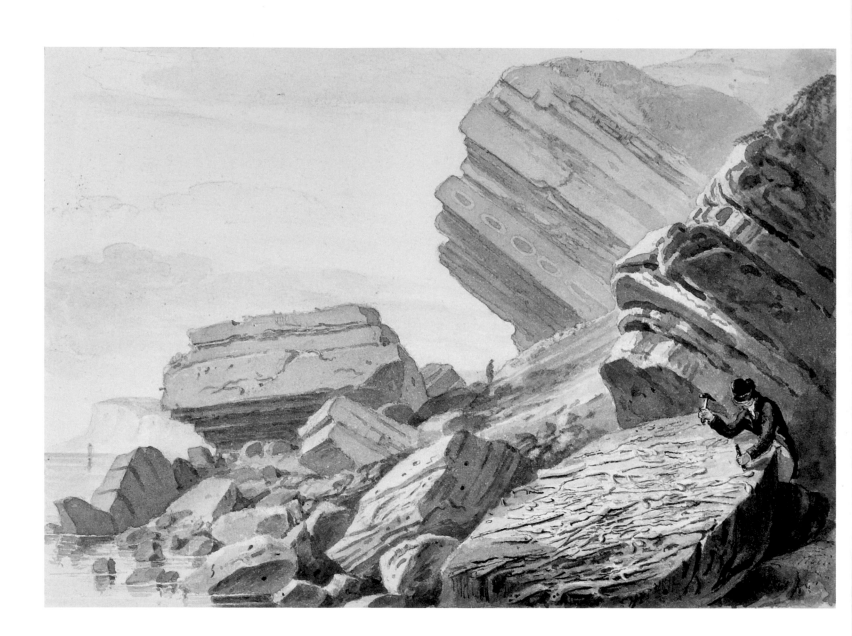

PAST TIME

GEOLOGY IN EUROPEAN AND AMERICAN ART

PATRICIA PHAGAN

WITH AN ESSAY BY JILL S. SCHNEIDERMAN

The Frances Lehman Loeb Art Center, Vassar College

In association with D Giles Limited, London

This catalogue accompanies the exhibition *Past Time: Geology in European and American Art* on display at The Frances Lehman Loeb Art Center, Vassar College, Poughkeepsie, New York from September 21 – December 9, 2018, and at the Herbert F. Johnson Museum of Art, Cornell University, Ithaca, New York from February 16 – May 12, 2019.

This catalogue and exhibition benefit from the generous support of the Art Dealers Association of America Foundation, the Evelyn Metzger Exhibition Fund, and the Lucy Maynard Salmon Research Fund, awarded by the Vassar College Research Committee.

© 2018 The Frances Lehman Loeb Art Center, Vassar College

First published in 2018 by GILES
An imprint of D Giles Limited
4 Crescent Stables
London SW15 2TN, UK
www.gilesltd.com

Library of Congress Control Number: 2017964717

ISBN: 978-0-9996837-0-5 (Softcover edition)
ISBN: 978-1-911282-36-5 (Hardcover edition)

All rights reserved

No part of the contents of this book may be reproduced, stored in a retrieval system, or transmitted in any form or by any means, electronic, mechanical, photocopying, recording, or otherwise, without the written permission of The Frances Lehman Loeb Art Center, Vassar College and D Giles Limited.

For The Frances Lehman Loeb Art Center:
Project Manager and Editor: Patricia Phagan
Photographs of works in the collection of The Frances Lehman Loeb Art Center are by Chip Porter
Additional photo credits: The Morgan Library & Museum, New York, cats. 8, 12, 43, back cover, pp. 36–37, 52–53
Other photo credits are in individual captions and catalogue entries.

For D Giles Limited:
Copy-edited and proofread by David Rose
Designed by Helen Swansbourne
Produced by GILES, an imprint of D Giles Limited, London
Printed and bound in Slovenia

All measurements are in inches and centimeters

Front cover:
Isaac Weld (Irish 1774–1856), *Vesuvius in Eruption*. Watercolor, gouache, graphite, and wash. Yale Center for British Art, Paul Mellon Collection B1981.25.2910. Detail of cat. 35

Back cover:
John Ruskin (British 1819–1900), *Study of Boulders*. Wash and graphite. The Morgan Library & Museum, 1974.49.284. Enlarged detail of cat. 12

Frontispiece:
Thomas Webster (British, b. Scotland 1773–1844), *Western Lines, Isle of Wight*, ca. 1811. Wash and graphite. Geological Society of London, LDGSL/400/20 Reproduced by permission of the Geological Society of London

Above: Enlarged detail of cat. 22

Olana State Historic Site is one of 35 historic properties administered and operated by New York State Office of Parks, Recreation and Historic Preservation; Andrew M. Cuomo, Governor.

CONTENTS

CATALOGUE
PATRICIA PHAGAN

FOREWORD

The exhibition *Past Time: Geology in European and American Art* strikes us as the sort of interdisciplinary exploration that modern higher education should be doing: a weaving and blending of the distinctive interests of art and science in the service of broadly synthetic learning. This is true to a certain extent, but it is good to remember that it was also central to the founding of the art collection at Vassar in the mid-nineteenth century, a time when polymathy was the pursuit of many learned individuals. The Baptist minister Elias Lyman Magoon, whose collection formed the nucleus of the art holdings of Vassar College, possessed a sensibility fascinated by art and the natural sciences that was typical of his age. In these two realms he found the presence and the divinity of the Godhead and the perfection of His creations in nature. As he set about forming his collection of paintings and works on paper during the 1840s and '50s, he sought out portrayals of the still pristine regions of America's northeastern states and the historic landscapes and monuments of the Old World. He remarked that as he was "born in the bosom of the Switzerland of America [he grew up in Lebanon, New Hampshire], innate taste for beauty blended in [his] heart with the love of nature." He commissioned agents and artists to provide him with drawings and watercolors of lithic wonders such as Fingal's Cave and Stonehenge as well as ruined abbeys perched on rocky cliffs. At a time when so much fervid scientific inquiry was being directed at the physical earth, Magoon's interest in synthesizing art with the physical and spiritual realms is quite understandable.

It is equally understandable that over one hundred and fifty years later we should have two scholars, Patricia Phagan, the Frances Lehman Loeb Art Center's curator of prints and drawings, and Jill Schneiderman, Vassar professor of earth science, joining forces to study the practical and theoretical contexts for artists' study of the sometimes dramatic and sometimes prosaic inorganic manifestations all around them. This shared inquiry ranges well beyond the art collection found at Vassar and we are grateful to the other public and private collections who have supported this project with their loans of works of art and natural specimens. We are also grateful to the funders of this exhibition, the Art Dealers Association of America Foundation, the Evelyn Metzger Exhibition Fund, and the Lucy Maynard Salmon Research Fund, awarded by the Vassar College Research Committee, as well as to our institutional partner, the Herbert F. Johnson Museum of Art at Cornell University, and our publishing partner, D Giles Limited, for making this project a reality.

JAMES MUNDY
The Anne Hendricks Bass Director
The Frances Lehman Loeb Art Center, Vassar College

Asher Brown Durand
"Dover Stone Church," Dover Plains, New York, ca. 1847
Graphite and white gouache on gray paper, mounted on card
Large detail of cat. 4

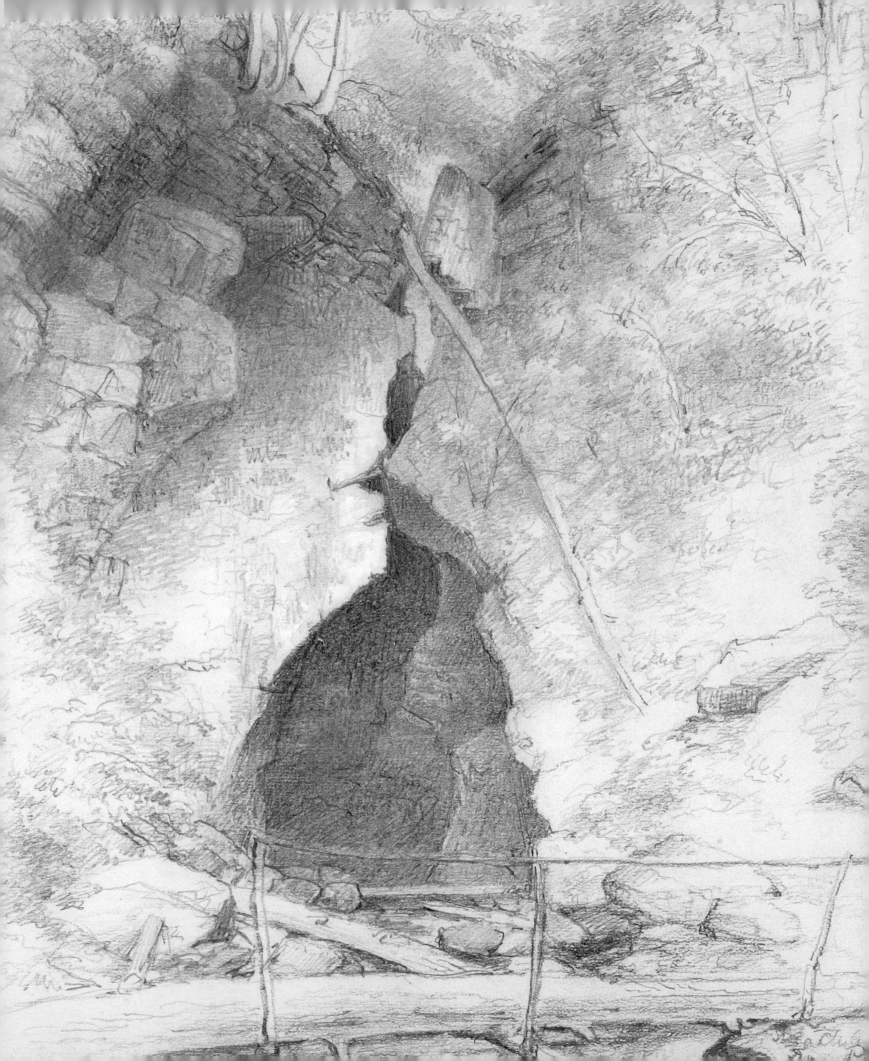

ACKNOWLEDGMENTS

The Frances Lehman Loeb Art Center is fortunate in having watercolors by the British nineteenth-century painter J. M. W. Turner in the permanent collection that were purchased directly from John Ruskin as well as a few drawings by the British art theorist himself. This present project began in 2013 when I looked anew at our watercolor by Ruskin, *Church of the Annunciation at Vico Equense on the Bay of Naples*, of 1841 (cat. 46). I became intrigued by Ruskin's delight in the grand sight of the town Vico Equense on top of a bold "rock promontory, orange and olive" and by his use of the local word *tufa* to describe the volcanic tuff rocks of the area. What is *tufa*, I wondered. Thus began research into Ruskin and other artists, long before and after, who responded in their sketches from nature to the accelerating presence of geology as a new scientific way of looking at the earth.

Writing in 1864, trustee Elias Lyman Magoon, the purchaser of those Turner watercolors, referenced geology while contrasting art and science in his report on "The Art Gallery" at Vassar College. As chairman of the art gallery committee, he submitted, "Geology uncovers the surface of time, as astronomy reveals the surface of space." Geology was an academic discipline by the time Magoon wrote his report. It was taught at Vassar College from the beginning of classes in September 1865, by Sanborn Tenney, Professor of Natural History. A well-regarded cabinet of rocks and minerals had already been formed by 1862.

For the past few years, I have had the pleasure of working collaboratively with a present-day geologist at Vassar College, Jill S. Schneiderman, Professor of Earth Science and a valued consultant to this project. Generous with her comments, Jill has been an enthusiastic reader and contributor with her essay on the visual aspects of the geologist and the artist, and her descriptions of natural specimens, all enhanced by a refreshing perspective.

At Vassar the exhibition could not have been created without the generous support of James Mundy, director of the Frances Lehman Loeb Art Center. Likewise, I am indebted to the talented staff of the Art Center, including Joann Potter, Margaret Vetare, Karen Casey Hines, Francine Brown, Bruce Bundock, Eleanor White, and Elizabeth Nogrady, and to my student assistants Dylan Finley, Abigail Descoteaux, Libby Prosser, Kirk Patrick Testa, Anna Oehlkers, Lily Platt, Zoe Lemelson, and Pindyck Fellow Emma Jacobs. Professor of Art History Brian Lukacher in the Department of Art has been a gracious advisor and reader. I am thankful to him and to George Laws, of the Office of Communications, and Gary Hohenberger and Judith Dollenmayer in the Grants Office.

Lenders to the exhibition have been extraordinarily generous. At the Yale Center for British Art I thank Amy Meyers, Scott Wilcox, and Maria Singer. At Cooper Hewitt I am grateful to Caroline Baumann, Caitlin Condell, Caroline O'Connell, and Janice Hussain. James Steward and Laura Giles at Princeton University Art Museum have

been enthusiastic lenders. At Olana and the New York State Office of Parks, Recreation and Historic Preservation, we have enjoyed the support of Valerie Balint, Ida Brier, Christopher Flagg, Ronna Dixson, and Heidi Miksch. Louise Mirrer, Roberta Olson, and Amanda Thompson at the New-York Historical Society have been generous supporters, as have Colin Bailey, Jennifer Tonkovich, Zoe Watnick, Giada Damen, Sophie Worley, Marilyn Palmeri, and Kaitlin Krieg at the Morgan Library and Museum. At the Metropolitan Museum of Art I thank Daniel Weiss, Asher Miller, Stephanie Herdrich, Catherine Mackay, Nadine Orenstein, Freyda Spira, Constance McPhee, Mary Zuber, Julie Zeftel, and Meghan Brown. Matthew Teitelbaum, Erica Hirschler, Helen Burnham, Patrick Murphy, and Caroline Cruthirds at the MFA Boston have also been very generous with their loans.

I am grateful to colleagues Caroline Lam at the Geological Society of London, Frank James and Jane Harrison at the Royal Institution, Wolfgang Hamm at the Staatsbibliothek Berlin, Nicola Hudson and Domniki Papadimitriou of Cambridge University Library, Ruby Hagerbaumer of Joslyn Art Museum, Frances Sands, Helen Dorey, and Joanna Tinworth of Sir John Soane's Museum, Eva Michel and Gisela Fischer at the Albertina, Julian Brooks of the Getty Museum, Thomas R. Paradise at the University of Arkansas, Marian Lupulescu of the New York State Museum, Rick Jones and Lois Horst of the Department of Earth Science and Geography, and Barbara Novak of Barnard College and Columbia University. I also offer my profound thanks to Ellen and Leonard Milberg and Dan Giles, and to Rebecca Bedell, Linda Ferber, and Emily Warner for reading the introductory essay.

We are greatly indebted to Stephanie Wiles and Nancy Green at the Herbert F. Johnson Museum of Art at Cornell University for their support and eagerness to partner with us on this exhibition. Our many thanks go to the Art Dealers Association of America Foundation, the Evelyn Metzger Exhibition Fund, and the Lucy Maynard Salmon Research Fund, awarded by the Vassar College Research Committee, for further generous support of *Past Time*.

PATRICIA PHAGAN
The Philip and Lynn Straus Curator of Prints and Drawings
The Frances Lehman Loeb Art Center, Vassar College

LENDERS TO THE EXHIBITION

Cooper Hewitt, Smithsonian Design Museum
The Metropolitan Museum of Art
The Morgan Library & Museum
Museum of Fine Arts, Boston
The New-York Historical Society
Olana State Historic Site, New York State Office of Parks, Recreation and Historic Preservation
Princeton University Art Museum
A. Scott Warthin Geological Museum, Vassar College
Yale Center for British Art

AN INTRODUCTION

PATRICIA PHAGAN

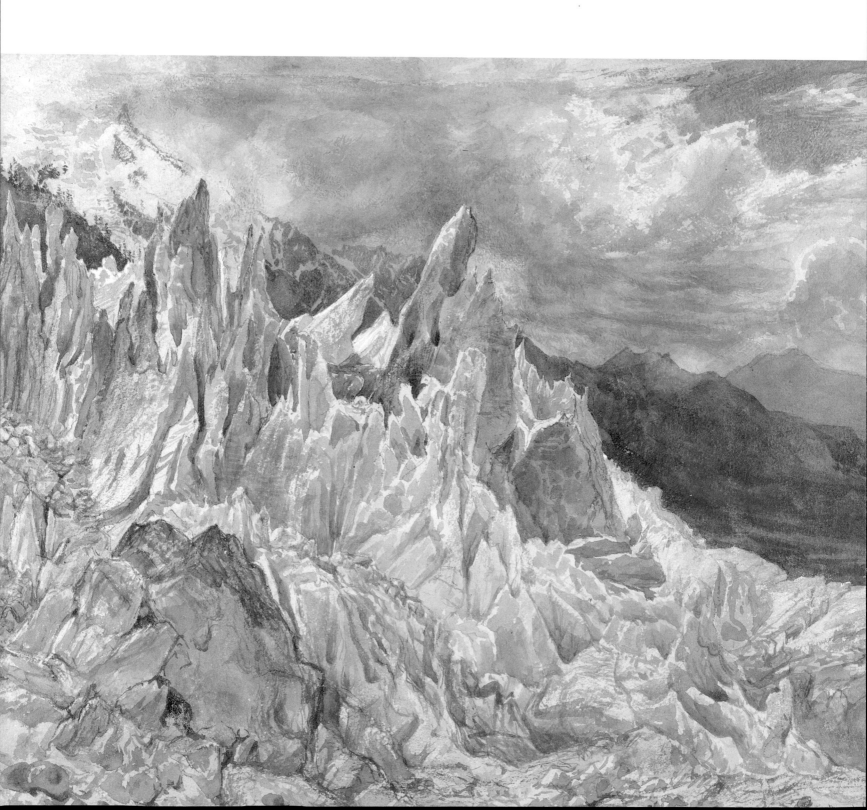

Past Time looks at sketches and studies made by European and American artists from the 1770s to the 1890s who were engaged with a new scientific investigation of the earth. Western artistic interest in the elemental features of the earth's crust—its hard, outer layers of rocks—rose to great heights in the late eighteenth century and the nineteenth as modern geology developed and became popular among wide audiences in Europe and America.[1] In this arguably golden age of art and science, artists traveled and explored the land internationally, taking keen note of earth's prominent surface features in their watercolors, drawings, and oil sketches. These media enabled freshness, spontaneity, and convenience for artists and travelers observing and transcribing nature.

GEOLOGY ATTRACTS ARTISTS

In the late eighteenth century and the nineteenth, open-air sketching and scientific observation of the terrestrial environment converged. This shared fascination with the earth's topography became the common ground between the artist and the geologist (as Jill S. Schneiderman explores in her essay in this volume), and this is evident with the drawings made by the topographer John Webber and geologist William Day during their hike in Derbyshire in the 1780s (cats. 5, 6). Travel allowed this confluence of the artistic and scientific to prosper, through fact-finding hikes, journeys, expeditions, and exploratory Grand Tours.

From at least the 1770s some artists became aware of new developments in geology through their friendships, such as that between Joseph Wright of Derby and his friend and neighbor, natural philosopher John Whitehurst (1713–1788). After years of fieldwork and gathering observations of miners, Whitehurst incorporated his researches into the geology of the rolling, craggy countryside near Derby into his book about the formation of the earth, published in 1778.[2] He distilled his observations on strata with cross-section illustrations that showed contoured shapes of cliffs and hills sliced vertically, revealing an orderly sequence of layers of rocks, each type and direction identified by numbers and a system of dots, hatched lines, crosshatchings, and so on.

Having a deep interest in natural science, Wright demonstrated a shared curiosity about caves in the area. With his detailed topographical drawing of the Dove Holes entrance in Dovedale, dated 1773, he directed attention to the cave's heavy, rough, and stained rock walls and at the

Henry Moore
Mer de Glace, 1856
Watercolor and gouache over graphite
Detail of cat. 32

11

Fig. 1. Sir William Hamilton (1730–1803), Plate VIII: *Representation of a Thick Stratum of Lava...*, from *Campi Phlegræi: Observations on the Volcanos of the Two Sicilies*, Naples, [s.n.], 1776, hand-colored etching after Peter Fabris, Yale Center for British Art, Paul Mellon Collection, T 161.855 (Folio A)

same time projected an evocative, dark, swallowing mouth (cat. 1). While his drawing analyzed the surface of the cave and glimpses into its mouth, the section drawings by Whitehurst of cliffs and hills delved beneath in a pioneering assessment of what lay under the surface. It seems clear that his friendship with Wright was richly supported with similar interests that they investigated in different ways. For instance, visiting Mount Vesuvius the following year, Wright wished Whitehurst had been with him to tell him about the "bowels" of the volcano.[3] In fact, Mount Vesuvius had figured strongly in Whitehurst's treatise regarding the massive effects of volcanic eruptions, with long passages quoted from naturalist Sir William Hamilton's recent study on the volcano.

Drawn by several eruptions of Mount Vesuvius in the mid-eighteenth century, Hamilton (1730–1803) made an intensive study of the strata at and around Mount Vesuvius in his spectacularly illustrated publication, *Campi Phlegræi: Observations on the Volcanos of the Two Sicilies*, published in Naples in 1776. The text and images contributed to the

interest among artists in Rome in natural history. Hamilton employed numerous itinerant artists from Britain and continental Europe for his geological and antiquarian projects. He directed and oversaw Peter Fabris (fl. 1756–84) in making a series of gouache drawings after nature for the hand-colored etchings that appeared in *Campi Phlegræi*. The imposing, thick lava layers of the quarry shown in the volume's plate VIII (fig. 1), for instance, present rugged and beautifully delineated block-like rocks with horizontal and vertical cracks, in meticulous detail and color. They do so within an exacting topographical watercolor approach, "in which each stratum is represented in its proper colours... as are likewise the different specimens of Volcanick matter, such as lava's, Tufa's, pumice stones, ashes, sulphurs, salts etc...," wrote Hamilton about the images in his book.[4]

The empirical Enlightenment-era tradition of topographical drawing became widespread in the later eighteenth and the nineteenth centuries, converging with the popular tourist trade, the fashion for the picturesque, and the rise of natural science and geology. In their scientific drawings

geologists often deployed the conventions of this approach. As Barbara Maria Stafford postulates, the new, focused, "scientific way of seeing" of the eighteenth century became associated with the travel accounts of the period and the illustrations that accompanied them. Based on fact yet conventionalized, the topographical approach relied on a representation of a specific locale.[5] Of utilitarian use early on, it was taught to those in trades such as surveyors and mapmakers and to cadets at military academies, and focused on observing land accurately through pencil, ink, wash, and watercolor washes, often in preparation for making prints. Its deep, rich, and profitable history in Britain gave rise to an acclaimed watercolor movement and to antiquarian book projects documenting architectural antiquities. This long-lasting method of recording views spread to the young United States and underlies the documentary contour-line landscape sketching of Thomas Cole and the Hudson River School painters at mid-century.

One also sees a concentration of this artistic practice in Rome where there was great interest in geology in the decades around 1800 due to fascination with the eruptions of Mount Vesuvius, the surrounding volcanic landscape, and literature addressing it. For example, the prominent neo-classical landscape painter Jacob Philipp Hackert (cat. 16) worked with a topographical drawing technique charged with precision and with texture-evoking washes in studies picturing volcanic features around Rome. A meticulous naturalist painter, Hackert, in fact, became close friends with Johann Wolfgang von Goethe (1749–1832) when the famous writer journeyed to the city in 1786. With a great interest in granite and in earth-origin theories of geology, especially the work of Abraham Gottlob Werner

(1750–1817), Goethe had already made his own geological field trips to the Harz Mountains and Switzerland by that time.[6]

In the 1770s, Werner, the popular and widely influential mineralogist and lecturer at the Freiberg School of Mines, coined an alternative term *geognosy*, or earth history, for direct study of earth's crust. He codified the crust into a sequence of distinct and universal rock layers that he theorized had at various times precipitated from a universal, primordial ocean. His geognosy pervaded popular literature and culture in Germany in the late eighteenth century and early years of the nineteenth, and his influence in the region seems to have stimulated a greater connection between the local terrain, geology, and art. For example, topographical artists in the landscape painting capital of Dresden, two dozen miles from Freiberg, sought and portrayed the Elbe Sandstone Mountains, caves, and other local rocky features during the latter decades of the eighteenth century and early years of the 1800s. They included Johann Christian Reinhart (cat. 2), Johann Moritz Gottfried Jentzsch (cat. 44), and a young Caspar David Friedrich (1774–1840), who in the 1810s was deeply engaged in geological themes.[7]

The topographical mode of drawing was profoundly significant to geologists and to artists interested in the earth. Prussian naturalist and explorer Alexander von Humboldt (1769–1859), who had trained under Werner, carried travel journals to record topographically his expeditions through Central and South America from 1799 to 1804. Through field notebooks such as these, naturalists and geologists captured land contours and geological information on site during their excursions, which were usually made on foot during the summers.[8]

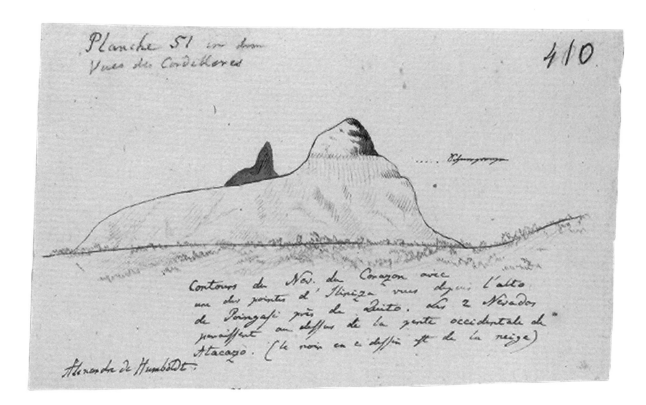

Fig. 2. Alexander von Humboldt, *Nes. du Corazon*, ink, wash, and graphite, page 410 [#802], Humboldt Diary VIIbb/c, 1801–02, Quito..., Staatsbibliothek zu Berlin. Photo Credit: bpk Bildagentur / Staatsbibliothek zu Berlin / Preußischer Kulturbesitz / Art Resource, NY

Humboldt's abbreviated sketch of the Corazón volcano, from his Quito, Ecuador, field notebook of 1801–02 (fig. 2), for example, shows an on-site freshness unlike the filled-in, studied print that appeared in his popular picture-book *Vues des Cordillères* (1810–13).[9]

Many of these and later naturalists, scholars, and explorers made informal sketches from intense field observations, sometimes elaborating on those drawings later by adding ink or crayon, for instance, and publishing them as prints in treatises, articles, and books about their journeys. They would frequently exaggerate what they saw, or many times add things that one could not see on the surface, making the drawings more diagrammatic.

Though field-drawing illustrations are limited in eighteenth-century literature, they often made their way into nineteenth-century scientific journals, treatises, books, and other outlets of literary culture.[10] Translated by professional printmakers into more elaborate and descriptive settings, as

with Humboldt's field drawings, they were often rendered as steel engravings—finely detailed designs on hard steel plates that frequently combined etching with engraving—as well as cheaper wood engravings and lithographs. These published drawings found receptive audiences among the scientific, ministerial, medical and professional classes and the educated elite.[11]

Soon after Humboldt's trip to Ecuador, in summer 1804 the Cornwall-reared Humphry Davy (1778–1829), charismatic professor of chemistry at London's Royal Institution, made a field trip to the northern British countryside to collect minerals and study geology and agriculture. The journey was in preparation for the ten lectures on geology he gave the following year to affluent general audiences at the Institution.[12] By summer 1805 he had visited the fabled basalt-columned Giant's Causeway in Ireland where his geological "expectations were fully satisfied," but he was unsatisfied with any explanation

of how the basalt columns were formed, a circumstance indicative of the controversy surrounding the origins— whether igneous or aqueous—of the rock.[13] An undated field drawing by Davy of basalt and chalk cliffs near the Giant's Causeway (fig. 3) shows his quick grasp of essentials through simple contour lines and shading (for basalt, see cat. 24b).[14] Davy drew in the widespread topographical approach, and a look through his field notebooks at the Royal Institution shows his drawings were frequently highly abbreviated and loose, executed very quickly, sometimes, it seems, without looking at the paper.

Many of the works in this exhibition are ultimately rooted within this vast, worldwide travel account literature and illustrations dependent on describing the topography of the land accurately. Views, or *vedute*, of caverns, natural arches, rocks, mountains, volcanoes, and cliffs in elaborate settings abound in the popular, published travel engravings, etchings, color aquatints, lithographs, and wood engravings of the late eighteenth and early nineteenth centuries and coincide with the rise of geological field drawings and the printed illustrations made after them, and the new, more focused, scientific way of looking.[15]

These topographic landscapes have much earlier precedents, however, in studies of stratified cliffs by Albrecht Dürer (1471-1528) and Leonardo da Vinci (1452-1519) and rocky outcrops by Leonardo and Baccio Bandinelli (1493-1560), for instance. Dürer's friend, Flemish painter Joachim Patinir (ca. 1480-1524) rendered steep rocks based on real life and treacherous alpine peaks in his altarpiece *The Penitence of Saint Jerome* (Metropolitan Museum of Art), set within a pilgrimage narrative that was a pivotal step toward the new landscape genre, and Prague

émigré draughtsman and prolific printmaker Wenceslaus Hollar (1607-1677) rendered the dramatic chalk White Cliffs of Dover, England (fig. 4) in an etching from his set of prints called *Divers Views after the Life* of 1676.[16] Indeed, Hollar imported the topographical method into England in the seventeenth century.[17]

Some of these landscape subjects would become enmeshed in the controversial geological theories of the late eighteenth century and the nineteenth. The mechanisms of mountain formation was a central issue, for example, with debates raging as to whether they rose through violent actions of volcanoes or through accumulations of sediments in primordial seas. Additionally, while interpretations of rock formations were continually being voiced, the formation of basalt and glacial erratics, those boulders that rest in peculiar spots and seem to be out of place, defied consensus. In addition, caves allowed extensive studies of fossils and gave access, literally, to the history of the earth. Cliffs, with their surfaces exposed by erosive processes, were often considered natural sections of vertical rock, whereas some natural arches were considered to have been caves that were eroded by wind, water, and other forces. My thanks to geologist Jill Schneiderman for confirmation of this information on cliffs and natural arches.

A practice in Europe and the United States of creating open-air landscape oil sketches also became a vehicle for closer looking at geological motifs. Artists in Italy could make volcanic cliffs, for instance, even more lifelike through the opaque, buttery qualities of oil paint, in works that were part of the preparatory process of painting and honing one's eye. The seventeenth- and early eighteenth-century art critic Roger de Piles (1635-1709) championed

ABOVE: Fig. 3. Humphry Davy, *Sketch of ... Cliffs near the Giants Causeway*, graphite, from Field Notebook, Ireland /Geology, n.d., Courtesy of the Royal Institution of Great Britain, RI MS HD/15A

BELOW: Fig. 4. Wenceslaus Hollar (Bohemian 1607–1677), *The Clyff of Dover*, from *Divers Views after Life*, 1676, etching, Frances Lehman Loeb Art Center, Gift of Matthew Vassar, 1864.2.94.b

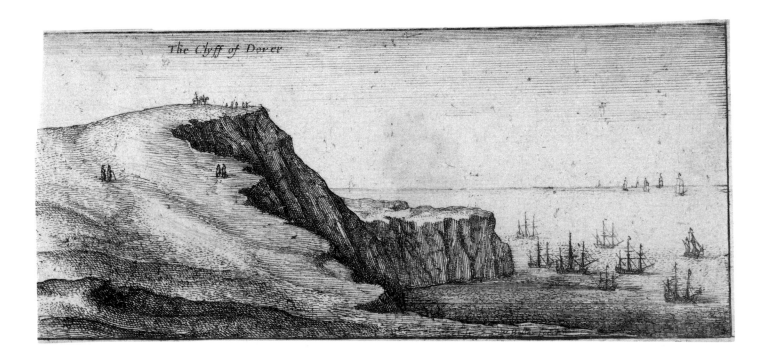

the practice in his *Cours de peinture par principes*, and the French Academy at Rome endorsed it, but its grand impact there was due largely to the informal, outdoor oils on paper of neo-classical painter Pierre-Henri de Valenciennes (1750–1819) and Thomas Jones (cat. 11), the latter deeply interested in geology. Through them and the still vital example of *Campi Phlegræi*, a greater emphasis on painted plein-air sketching of the rocky landscape took hold around Rome in the late eighteenth century and developed onward.[18] Colonies of especially French and German artists but also British, Scandinavian, American, and other international artists formed in Rome. Painters and draughtsmen traveled to the local mountains or made side trips to the Grotto of Posillipo (cat. 45), Mount Vesuvius, and the ravine at Sorrento (cat. 3), among other favorite

sites to make sketches *en plein air* from an abundance of unusual formations. In his popular how-to-paint-landscape treatise *Élémens de perspective pratique*, published in Paris in 1800, Valenciennes advised rendering detail and tone quickly in informal *études* directly from nature.[19] The artist's approach fanned out to France and other European countries.

A strong tradition of outdoors landscape painting formed in Düsseldorf, a training ground for international artists attracted to the Academy there and its reputation for instilling a rigorous adherence to precise, minute observation, especially in the early to mid-nineteenth century. At mid-century, several American painters including Albert Bierstadt traveled to Düsseldorf. They especially gravitated toward meeting in the studio of the

meticulous Düsseldorf mountain-landscape painter Karl Friedrich Lessing (1808–1880) and then sketching in the countryside during the summers.[20]

Meanwhile, in Dresden, Friedrich's student, the naturalistic painter, doctor, and scientific illustrator Carl Gustav Carus (1789–1869), became inspired by his friend Humboldt's writings. Carus called in his *Nine Letters on Landscape Painting, Written in the Years 1815–1824* (1831) for landscapes that delved deeply into the life, history, science, and the structure of the earth, what he called *Erdlebenbildkunst*, or "earth-life art."[21] As if on cue, with the growing acceptance of the ideas of British geologist Charles Lyell (1797–1875) who argued that the earth had undergone a very long series of gradual changes, painters in Germany and elsewhere began picturing in greater numbers the incremental and sometimes monumental results of the crust's changes over time through the forces of wind, water, and ice.[22]

We find oil sketches made in the open air in the United States as well, where Hudson River School artists, led early on by geology enthusiast Cole, generated sketches and studies of both the American mountain wilderness and rugged features abroad. Durand, who became the leader of the school after Cole's death in 1848, became one of the many followers of John Ruskin's precision-seeking "truth to nature" mandate. As a consequence, Durand and others he inspired through his "Letters on Landscape-Painting" in the magazine *The Crayon* made open-air landscape-painting excursions, rendering craggy, rocky phenomena along with natural forces of erosion, including form-changing waves, running creeks, and spewing falls in almost mirror-like detail.

Ruskin advocated for such closely observed naturalism in his first volume of *Modern Painters*, published in London in 1843. Geology was the key to a better understanding of nature, the Englishman declared. As he pointed out in the preface to the second edition of the volume (1844), geological and botanical details invigorate the work of art and bring it closer to a real ideal, not one generalized or stylized. For Ruskin the ideal landscape was the "expression of the specific—not the individual, but the specific—characters of every object, in their perfection.... Every landscape painter should know the specific characters of every object he has to represent, rock, flower, or cloud...."[23]

Ruskin's treatise on landscape painting was remarkable for the effect that his assertive, energetic voice and thinking had on a generation of European and American painters in the middle of the nineteenth century drawn to the writer's mellifluous words and embrace of geological detail. Indeed, the Düsseldorf-trained Hudson River School painter Worthington Whittredge remembered that Ruskin's *Modern Painters* was "in every landscape painter's pocket."[24] The painstaking, geological landscapes of the British Pre-Raphaelite painters and their followers in Britain such as John Brett (cat. 9) and in the United States such as William Trost Richards (cats. 8, 48, 49) testify to the impact of Ruskin on their more exacting outdoors sketches and more finished paintings. On the other hand, these painters' ancient crumbling cliffs and natural arches at seaside testify to the powers of water and wind. The startlingly lifelike drawings and watercolors by these artists and others in the middle and later years of the nineteenth century demonstrate the hold that the British writer and thinker had on landscape drawing and painting for at least half a century.

POPULARITY OF GEOLOGY IN EUROPE AND THE UNITED STATES

By the 1850s an awareness of geology surged. This popularity first surfaced in German-speaking lands where natural science journals were already plentiful in the eighteenth century. General weeklies and popular journals there also fed a broad public appetite for news and articles on the natural sciences, not surprising given the widespread popularity of the lectures by Werner.[25] A growing literature on minerals and geology contributed to the formation of mineralogical societies, which were fashionable among the middle and upper classes, and to geology as an independent discipline.[26]

On another front, in 1807 Humphry Davy became a founding member of the Geological Society of London, soon the dominant institution in the nineteenth century behind the pursuit of geological field research. Although resistant in its early years to promulgating speculative theories of the earth, as many were doing, nevertheless, the society was the first organization dedicated to observations of earth's features and the mapping, drawing, and order of the rocky crust, as exemplified by artist-member Thomas Webster (see frontispiece).[27] This new, practical science of geology reached a fashionable status with the British public years later, however, and the climb appears to have been gradual.

In 1808 Geological Society members wrote a pamphlet *Geological Inquiries*, asking the public to search for and send them specimens and observations from the field.[28] By the late 1810s members embraced theories like the biblical Deluge that appealed to larger, influential audiences, including the clergy and the wealthy.[29] At the time popular

writers such as Anne Plumptre and Thomas Walford, through their outings in Britain, revealed vivid interests in geological sites, rocks, and minerals. They and other writers furthered the ties between tourism, the obsession with geological observation, and the nationalistic fervor for boosting certain regions through their accounts of geological wonders.[30] By 1822 the Council of the Geological Society, to make their work more accessible, decided to transform its publication *Transactions of the Geological Society* into a new series, in part by using lithography for illustrations wherever it was possible, rather than the more expensive prints produced with metal plates.[31] Finally, by the 1830s, geology reached celebrity status in Britain, aided by popular texts and lectures, including the highly accessible *Principles of Geology* (1830–33) by Lyell, and entertaining lectures on the theory of catastrophism by Oxford University professor, theologian, and geologist William Buckland (1784–1856). President of the popularizing British Association for the Advancement of Science, like several leading minister-geologists Buckland favored a scripture-based geology even while he championed the new science's empirical methods. He even directed the young Ruskin in making drawings for his lectures. Numerous books were influential in catching the attention of a wide swath of the public. These included Scottish stonemason and editor Hugh Miller's (1802–1856) evocative, visual-prose-filled *The Old Red Sandstone; or New Walks in an Old Field*, first published in 1841.[32] Cheaper serial publications like the *Penny Magazine* and *Illustrated London News* also spread the subject to much wider audiences starting in the 1830s and '40s.[33]

As with travel, geology in the British Victorian Age remained popular as a pastime, attracting generations of the

upper-middle and upper classes, who had means and time in varying degree, to make discriminating observations in the field. They also traveled abroad to see for themselves the crater of Mount Vesuvius (fig. 5) and other well-known geological sites, and they visited the crowd-pleasing geology exhibits at the 1851 Crystal Palace in London's Hyde Park. The popularity of geology reached such heights in Britain that texts, puns, and caricatures appeared, satirizing the language, class interest, and section drawings associated with geology. Catherine Mary Webber (1831–1900), for instance, designed an accordion booklet of satirical lithographs in 1859, visually punning on section drawings, including an "'Antient Crater' showing Traces of eruption" (fig. 6).[34]

By 1834 in the United States, geology was seen as "the fashionable science of the day, and may be said to form a necessary part of practical and ornamental education," according to a writer in *The Knickerbocker* magazine, which embraced reviews on geological texts, popular articles on leading scientists, and travelogues to Mount Vesuvius and other sites.[35] Official state-sponsored surveys also began taking place in the 1830s and '40s during the height of geology's popularity in the United States, although even by the latter decade geology writings were already beginning to be more scientific and specialized. William W. Mather (1804–1859), who trained and taught geology at West Point Military Academy along the Hudson River, surveyed almost two-dozen counties in the eastern parts of New York State. His massive study, published in 1843, featured hand-colored lithographs of section drawings showing the various kinds of strata he encountered (fig. 7).

In the 1850s a federal survey for building a railroad out West documented routes and geological formations, and postwar federal surveys recorded the geological features of the western territories and featured well-known artist-topographers such as Thomas Moran and Sanford

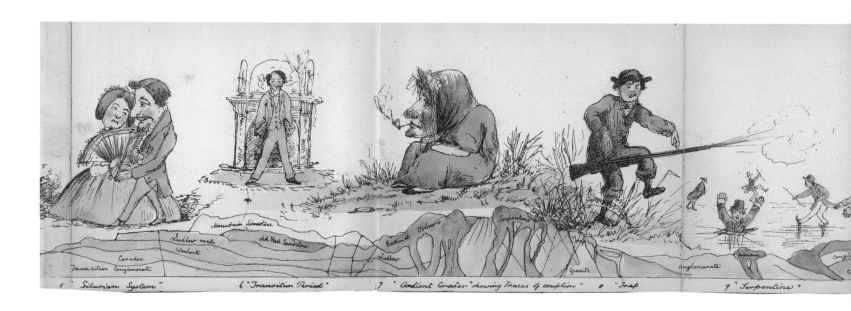

RIGHT: Fig. 5. Giacomo Brogi, *Men and Women on the Summit of Vesuvius* (large detail), albumen print from glass plate negative, later printing (1895), Frances Lehman Loeb Art Center, Transfer from Vassar College Libraries, Gift of the Charles F. Smillie Collection of Photographs presented by Mrs. Mary Smillie Throop, 1994.16.11

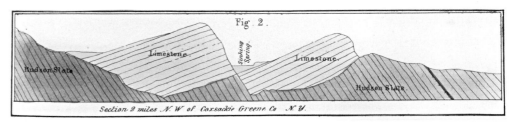

BELOW: Fig. 6. C. M. W. [Catherine Mary Webber], Scenes from *Geology Familiarly Illustrated*, 1859, lithograph and gouache, accordion book, Yale Center for British Art, Rare Books and Manuscripts

ABOVE: Fig. 7. Truman Seymour, *Section 2 miles N.W. of Coxsackie Greene Co. N.Y.*, lithograph and gouache, plate 8, fig. 2, in William W. Mather, *Geology of New-York*, Albany, 1843, Vassar College Libraries

Robinson Gifford. Finally, in 1879 the United States Geological Survey was formed, and in 1888 the Geological Society of America was established. Even into the 1880s and '90s, American artists in their oil sketches and drawings were still thinking about geology as a consequence of their travels out West.

In the end, this broad sweep of new interest in the crust of the earth was international and long-lasting, originating in the empirical age of the Enlightenment when natural historians, geologists, and artists carefully recorded geological phenomena through their texts, fine-art drawings, or geological illustrations translated into published prints. This interest widened with the great popularity and accessibility of geology through the Romantic era in Europe and America and into the post-Civil War epoch.

With the gradual and widening popularity of geology, more artists became engaged with geological motifs as the new discipline became more accessible through popular literature and printed illustrations. Indeed, by the 1830s in Europe and the United States many artists knew about geology as part of their overall education, and the concept of slow, incremental change over a vast geological time, as espoused by Charles Lyell, began to be accepted. Artists took various routes, however, in their approach to engaging with geology. From a topographical, often strata-focused interest to a later mode that evoked nature's great transformational powers over time, European and American artists pursued their cross-cultural travels in seeking geological wonders. For both artists and geologists, the search encompassed not only the external study of visible surfaces of the earth but also hypothetical theories about the mysteries of time and nature that lay beneath.

Sanford Robinson Gifford
Evan's Hill, August 12, 1859
Graphite on beige wove paper
Detail of cat. 19

1. On geology and European and American art, see especially Rebecca Bedell, "The History of the Earth: Darwin, Geology and Landscape Art," in *Endless Forms: Charles Darwin, Natural Science and the Visual Arts*, ed. Diana Donald and Jane Munro (Cambridge: Fitzwilliam Museum; New Haven: Yale Center for British Art, 2009), 48–79; Bedell, *The Anatomy of Nature: Geology and American Landscape Painting, 1825–1875* (Princeton and Oxford: Princeton University Press, 2001); Stephen Jay Gould, "Church, Humboldt, and Darwin: The Tension and Harmony of Art and Science," in *Frederic Edwin Church*, by Franklin Kelly, with Stephen Jay Gould, James Anthony Ryan, and Debora Rindge (Washington, D.C.: National Gallery of Art, 1989), 94–107; Katherine Manthorne, *Creation and Renewal* (Washington, D.C.: National Museum of American Art, Smithsonian Institution Press, 1985); Barbara Novak, *Nature and Culture: American Landscape and Painting 1825–1875*, 3rd ed. (New York and Oxford: Oxford University Press, 2007); and *American Art* 31, no. 2 (Summer 2017): 32–61, featuring current studies on American landscape.

2. John Whitehurst, *Inquiry into the Original State and Formation of the Earth* (London: Printed for the author, and W. Bent, by J. Cooper, 1778).

3. Joseph Wright to Richard Wright, Rome, 11 November 1774, in Elizabeth Barker, "Documents Relating to Joseph Wright of Derby (1734–97)," *Walpole Society* LXI (2009), 84.

4. Sir William Hamilton, *Campi Phlegræi, Observations on the Volcanos of the Two Sicilies* (Naples, 1776), 5. See the entry on the book in Ian Jenkins and Kim Sloan, *Vases and Volcanoes: Sir William Hamilton and His Collection* (London: British Museum Press, 1996), 165–68. In the same volume, see the interesting essay by John Thackray, "'The Modern Pliny': Hamilton and Vesuvius," 65–74.

5. Barbara Maria Stafford, *Voyage into Substance: Art, Science, Nature, and the Illustrated Travel Account, 1760–1840* (Cambridge, MA, and London: MIT Press, 1984), 40, 47.

6. See W. Scott Baldridge, "The Geological Writings of Goethe," *American Scientist* 72, no. 2 (March–April 1984): 163–67; and Johann Wolfgang von Goethe, *Scientific Studies*, ed. and trans. Douglas Miller (New York: Suhrkamp Publishers, 1988), 131–40.

7. Albert Boime, *Art in an Age of Bonapartism 1800–1815* (Chicago and London: University of Chicago Press, 1990), 519. On Friedrich and geognosy, see Timothy Mitchell, "Caspar David Friedrich's *Der Watzmann*: German Romantic Painting and Historical Geology," *Art Bulletin* 66, no. 3 (1984): 452–64. On Friedrich and rocks, see Tina Grütter, *Melancholie und Abgrund* (Berlin: Dietrich Reimer Verlag, 1986).

8. On fieldwork, see Martin J. S. Rudwick, *The Great Devonian Controversy* (Chicago and London: University of Chicago Press, 1985), 37–41; and Rudwick, *Bursting the Limits of Time* (Chicago and London: University of Chicago Press, 2005), 73–80.

9. Alexander von Humboldt, *Views of the Cordilleras and Monuments of the Indigenous Peoples of the Americas*, ed. Vera M. Kutzinski and Ottmar Ette (Chicago and London: University of Chicago Press, 2012), plate LI. For Humboldt's field books, see the Alexander von Humboldt Portal, http://humboldt.staatsbibliothek-berlin.de.

10. Ralph O'Connor, *The Earth on Show* (Chicago and London: University of Chicago Press, 2007), 13.

11. The online, digital Field Book Project for field books held across the different repositories of the Smithsonian Institution is very helpful for seeing a range of nineteenth- and twentieth-century field books: http://biodivlib.wikispaces.com. On the history of published geological illustrations, see Martin J. S. Rudwick, "The Emergence of a Visual Language for Geological Science 1760–1840," in *The New Science of Geology* (Aldershot, Hampshire, and Burlington, VT: Ashgate, 2004), 149–95.

12. Robert Siegfried and R. H. Dott, Jr., "Humphry Davy as Geologist, 1805–29," *British Journal for the History of Science*, 9, no. 2 (July 1976): 219–20.

13. H. Davy to Davies Giddy, Esq., September 1805, Okehampton, in John Ayrton Paris, *The Life of Sir Humphry Davy, Bart. LL.D.*, vol. 1 (London: Henry Colburn and Richard Bentley, 1831), 132.

14. I am very grateful to Frank James of the Royal Institution, London, for his suggestion to view Davy's field notebooks.

15. See the very helpful and thorough study on travel illustrations by Stafford.

16. Albrecht Dürer, *Rocky Formation*, ca. 1494, watercolor and gouache, British Museum, Sloane Collection; Leonardo da Vinci, *A Rocky Ravine*, ca. 1475–80, ink, and *Horizontal Outcrop of Rock*, ca. 1510–13, ink over chalk, Royal Collection; Baccio Bandinelli, *A Rocky Outcrop*, brown ink, Metropolitan Museum of Art. For the concept of landscape and its early relation to travel and description, see E. H. Gombrich, "The Renaissance Theory of Art and the Rise of Landscape," in *Norm and Form* (London: Phaidon Press, 1966), 107–21. For an interesting overview of geology and works by Dürer and Hendrick Goltzius, see Gary D. Rosenberg, "The Measure of Man and Landscape in the Renaissance and Scientific Revolution," in *The Revolution in Geology from the Renaissance to the Enlightenment*, ed. Gary D. Rosenberg, Geological Society of America Memoirs 203 (Boulder, CO: Geological Society of America, 2009), 13–40. For an overview of the mountain in Old Master painting and drawing, see Bettina Hausler, *Der Berg: Schrecken und Faszination* (Munich: Hirmer Verlag, 2008), 6–41.

17. See Anna Austen, "Intimate Knowledge," and catalogue entry no. 5, in Alison Smith, ed., *Watercolour* (London: Tate Publishing, 2011), 38–39, 44–45; and Felicity Myrone, "British Topography: 'Our Real National Art Form'?," www.bl.uk/picturing-places/articles.

18. Theodore E. Stebbins, Jr., *The Lure of Italy* (Boston: Museum of Fine Arts, 1992), 46; Peter Galassi, *Corot in Italy* (New Haven and London: Yale University Press, 1991), 16–21, 27–31. See also *Paysages d'Italie: Les peintres du plein air, 1780–1830* (Paris: Galeries nationales du Grand Palais; Mantua: Centro Internazionale d'Arte e di Cultura di Palazzo Te, 2001) and *In the Light of Italy* (Washington, D.C.: National Gallery of Art; New Haven and London: Yale University Press, 1996).

19. P. H. Valenciennes, *Élémens de perspective pratique* (Paris: The Author, Desenne, and Duprat, 1800), 404–09.

20. Donelson F. Hoopes, *The Düsseldorf Academy and the Americans* (Atlanta, GA: High Museum of Art, 1972), 21–22, 27, 31; Timothy F. Mitchell, *Art and Science in German Landscape Painting, 1770–1840* (Oxford: Clarendon Press, 1993), 157.

21. Carl Gustav Carus, *Nine Letters on Landscape Painting, Written in the Years 1815–1824* (Los Angeles: Getty Research Institute, 2002), 118–19.

22. See Mitchell, *Art and Science*, 180–205.

23. John Ruskin, *Modern Painters*, 2nd ed. (London: Smith, Elder and Co., 1844), xxxviii.

24. Worthington Whittredge, manuscript of Autobiography, Worthington Whittredge Papers, Box 1, Folder 6, 55/70, Archives of American Art, Smithsonian Institution.

25. David A. Kronick, *A History of Scientific and Technical Periodicals*, 2nd ed. (Metuchen, NJ: Scarecrow Press, 1976), 245–47.

26. Martin Guntau, "The Rise of Geology as a Science in Germany Around 1800," in *The Making of the Geological Society of London*, ed. C. L. E. Lewis and S. J. Knell, Geological Society Special Publication 317 (London: The Geological Society, 2009), 165, 174–75.

27. See Martin J. S. Rudwick, "The Early Geological Society of London in Its International Context," in *Making of the Geological Society*, 151; James A. Secord, *Controversy in Victorian Geology* (Princeton: Princeton University Press, 1986), 24; Ralph O'Connor, "Facts and Fancies: the Geological Society of London and the Wider Public, 1807–1837," in *Making of the Geological Society*, 331.

28. O'Connor, "Facts and Fancies," 332.

29. Ibid., 337.

30. Anne Plumptre, *Narrative of a Residence in Ireland* (London: Henry Colburn, 1817); and Thomas Walford, *The Scientific Tourist Through England, Wales, and Scotland* (London: J. Booth, 1818).

31. "Notice," *Transactions of the Geological Society of London*, series 2, vol. 1 (1822), 5.

32. Hugh Miller, *The Old Red Sandstone; or New Walks in an Old Field*, 2nd ed. (Edinburgh: John Johnstone; and London: R. Groombridge, 1842).

33. O'Connor, "Facts and Fancies," 338; O'Connor, *The Earth on Show*, 193, 195–96.

34. Catherine Mary Webber, *Geology Familiarly Illustrated* (London: J. B. Goodinge, 1859).

35. Samuel L. Metcalf, "The Interest and Importance of Scientific Geology as a Subject for Study," *The Knickerbocker* 3, no. 4 (April 1834): 227, quoted in Dennis R. Dean, "The Influence of Geology on American Literature and Thought," in *Two Hundred Years of Geology in America*, ed. Cecil J. Schneer (Hanover, NH: University Press of New England, 1979), 293.

VISUAL LANGUAGE
THE COMPLEMENTARITY OF GEOLOGY AND ART

JILL S. SCHNEIDERMAN

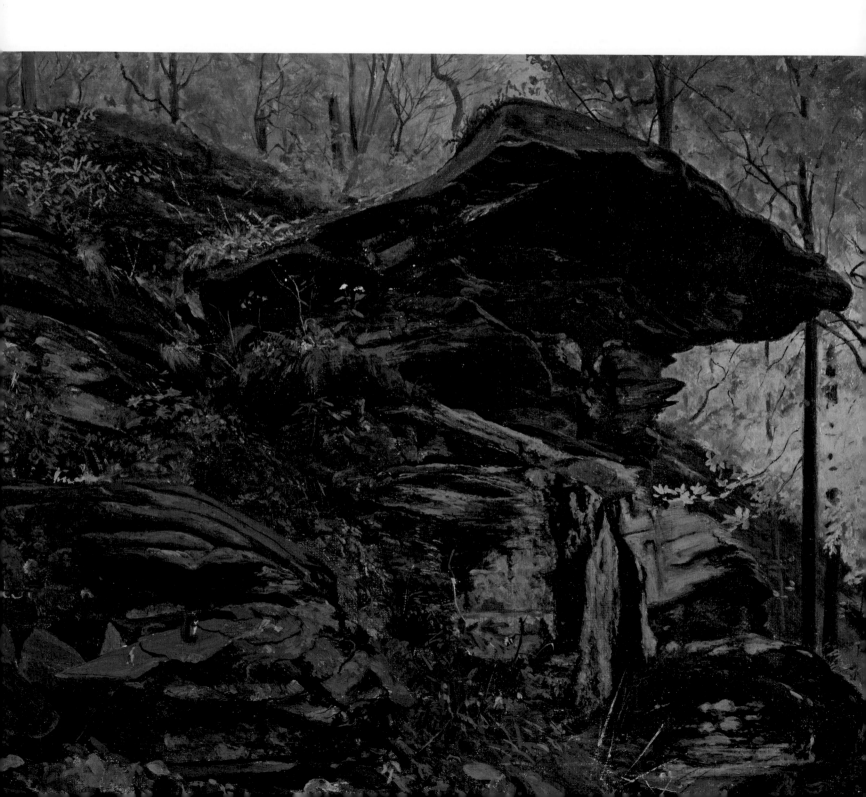

If I had the fortune to be an artist, I believe

I would endeavour to study geology on two

sides—first, as the science of form and expression

in mountains and rocks; secondly, as a poetic

interpretation of past time.

The landscape painter.... He must necessarily

scrutinize whatever is pregnant with interest

before he reproduces it on his canvas. ...and

consequently, although perhaps unintentionally,

he is a geologist.[1]

Fundamentally, geology is a visual science, and like artists, geologists use what historian of science Martin Rudwick has called "visual language," a phrase that resonates with art historian Matthew Johnston's phrase "image-language," to represent our observations of Earth's features and phenomena. Careful drawings heighten geologists' scientific understanding by opening up windows to our imaginations, while scientific observations enrich artists' depictions of natural landscapes.[2] German scientist and explorer Alexander von Humboldt (1769–1859) professed the unity of science and art, the complementarity of analysis and sentiment. He believed that a great painter must be committed to accurate and detailed examination of a subject. This exhibition allows viewers to examine the confluence of geology and artists' representations of rocky landscapes, whether mountainous, volcanic, glaciated, or subtly sculpted by erosive forces. As for me, since I am a field geologist and not an artist or art historian, I neither interpret nor judge these oil sketches, watercolors, and drawings. Instead, I offer my perspective on them in order to explore the interdependence of scientific and artistic modes of encountering the Earth.

As geologist Hugh Miller (1850–1896) wrote in his late nineteenth-century polemic *Landscape Geology: A Plea for the Study of Geology by Landscape-Painters,* geology is a "science not of dissection but of observation—not of the classroom but of the hillside; it appeals in endless ways to the reason and the imagination, tempting the mind to spread

Jervis McEntee
Rocks at the Corner, 1859
Oil on canvas
Detail of cat. 20

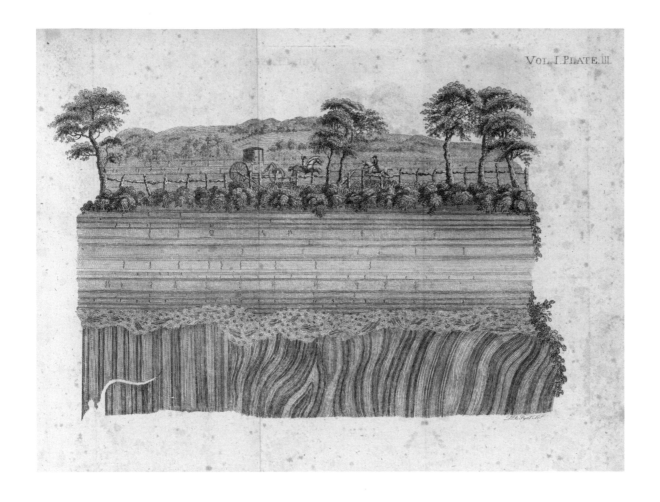

its wings into many picturesque regions both of time and surface, both of the past and the present."[3] In keeping with this reflection, visual inspection was crucial to the work of natural historians in the late eighteenth and early nineteenth centuries.[4] For example, plate 3 of *Theory of the Earth* (1795), the foundational work of eighteenth-century Scottish physician and gentleman-farmer James Hutton (1726–1797) that paved the way for the modern science of geology, reveals how essential is visual imagery for acquiring geological knowledge (fig. 1). In his treatise Hutton described observations of rock outcrops throughout Scotland. The image, an etching based on the drawing by John Clerk of Eldin (1728–1812), who accompanied Hutton on numerous field excursions in the period from 1785 to 1788, depicts an unconformity—a fossil surface of erosion, a gap in time distinguishing two periods in

the formation of rocks. It is the critical geologic structure for understanding Earth's history. The print depicts the simple geometry of horizontal sedimentary strata, or layers, overlying vertical strata and indicates two episodes of deposition of distinct types of sediment separated by a period of tumultuous uplift and erosion. This series of events must have taken thousands if not millions of years to occur, according to Hutton's thinking. The plate reveals the central tenet around which the book is built—the Earth's age is so vast that in Hutton's words "we find [on Earth] no vestige of a beginning,—no prospect of an end."[5]

During the period in which Hutton searched for concrete evidence for his theory that the Earth was older than imaginable, Clerk travelled with him at least in part to help record evidence for this radical theory. Only this etching of Clerk's drawing of the unconformity at Jedburgh

and a handful of his other drawings were incorporated into *Theory of the Earth*. However, additional drawings made by Clerk came to light two centuries later when a descendant found a folio containing some seventy geological drawings among the papers of the Clerk family.[6] These previously unknown illustrations of famous Scottish formations—many of them with very fine watercolor washes—were intended for use in a third volume of Hutton's *Theory*. According to Rudwick, "the lost drawings" of these other geologically significant landscapes reveal that Clerk, following in the tradition of Paul Sandby (1731–1809), an English survey topographer turned landscape painter, was an excellent draftsman who discerned the elements Hutton wished to indicate.[7]

Images from the sketchbooks of the Hudson River School painter Sanford Robinson Gifford (cats. 18, 19) testify to the fact that for artists, sketching serves as a primary means to appreciate and document Earth's physical features. Likewise, geological understanding depends on illustrations so as to augment written or verbal descriptions of the fossils, rocks, and geologic structures observed. Like artists' sketchbooks, the field notebooks of geologists then and now include numerous, if not copious, sketches and diagrams. All aspiring geologists are taught to include as essential elements in our field notebooks a sketch of the outcrop and detailed drawings of rock features we observe.

When I began my doctoral research in New England trying to explain outcrops such as those shown by Jervis McEntee in *Rocks at the Corner* (cat. 20 and detail, p. 24), my first step was to draw the landscape and rocks before me. On multiple visits to my field site, like McEntee I focused on planar structures referred to as "bedding" that formed rocky overhangs in the forest. In fact, we geologists go "into the field" time and time again, often to the same rocky outcrop, because, as noted German structural geologist Hans Cloos (1885–1951) wrote, "the previous impression had had time to settle, or because this time our eyes were a little keener and now observed what hitherto had escaped them."[8] An outcrop, even if seen previously and more than once, can still yield new information if sketched multiple times. As Cloos did for geologists, Humboldt did for artists in his influential treatise on science and nature, *Cosmos*. As quoted by art historian Barbara Novak, he advised:

> Colored sketches, taken directly from nature, are the only means by which the artist, on his return, may reproduce the character of distant regions in more elaborately finished pictures; and this object will be the more fully attained where the painter has, at the same time, drawn or painted directly from nature a large number of separate studies ... of rocks and of portions of the shore, and the soil of the forest.[9]

Therefore, the ability to draw, and often color, field sketches with some competence was and still is an important factor in geology as it was in art overwhelmingly in the eighteenth and nineteenth centuries.

As artists' sketches in the field often serve as pathways to subsequent visual renderings, the information geologists bring back from the field leads to interpretive representations such as geologic maps. Such visual images have a history that reaches back to 1801 when English geologist William "Strata" Smith (1769–1839) drafted a rough sketch

based on his field work of what later became known as "The Map that Changed the World"—the first geological map. Smith's detailed map published in 1815, *A Delineation of the Strata of England and Wales, with Part of Scotland*, measured eight and a half feet high by six feet across (fig. 2). Long bands of color of twenty different tints stretched across the map to represent layers of major sedimentary units both beneath and above ground extending from the English Channel to the Scottish border.

In the nineteenth century, maps and sections were printed from engraved and etched copper, and, later, steel plates. Though intended as visual scientific documents, they were inadvertent works of art. Areas bound by black outlines were colored by hand with numerous watercolors and inks. The colors used during that century to represent the different rock formations are still used as standards by geologists worldwide. The maps are tribute to the powers of observation and deduction of Victorian geologists who compiled this fundamentally correct interpretation of the complex and varied geology of the British Isles.

Following in this tradition, modern geologists create geological maps, too, casting their documents in a visual language. Geologists strive to depict on a two-dimensional surface the underlying three-dimensional structure of outcrops of rocks. Scientifically speaking, today's geologic maps reveal the distribution of rock types of different ages. Rocks are separated into formations—that is, rock types that are distinct enough to distinguish from other rocks in the area and thick enough to show accurately on the map. Each formation is represented by a unique symbol and color. This visual mode of description enables geological concepts to be rendered more adequately than if expressed using text alone. They testify to the significance of illustration in understanding and expressing scientific theories.

Artists' illustrations, too, have helped geologists organize and substantiate their geological narratives. This can be appreciated in the works of Thomas Moran, the landscape painter who created potent images from his travels with some of "The Great Surveys" of the American West. For seven weeks in 1873 Moran accompanied geologist John Wesley Powell (1834–1902) on the last of his expeditions to survey the Colorado River and its tributaries. Powell chronicled the geological changes that formed the unique topography of the West in the process of mapping unknown terrain as viable railroad routes across the country. Moran employed a geologically sensitive eye to sketch the landscape and captured the monumental scale of the land. His work helped enable Powell's story of the evolution of the region's topography.[10] Matthew Johnston has described Moran's landscape illustrations as a kind of "key" unlocking Powell's narrative.[11] Wood engravings based on sketches by Moran figure prominently in Powell's official report of the survey, thus spotlighting the effect of the artist on the scientist (fig. 3).

Moran must have been well prepared to capture the nature of the monumental terrain he would encounter with Powell, for in 1871 he had traveled west, headed for an expedition led by geologist Ferdinand Vandeveer Hayden to the uncharted Yellowstone area of Wyoming. Once Moran arrived in Yellowstone, land that was designated ultimately as the nation's first national park, he began to paint the extraordinary sights of what we know today to be the largest concentration of geysers in the world. Though his painting *Grand Canyon of the Yellowstone* (Smithsonian American Art

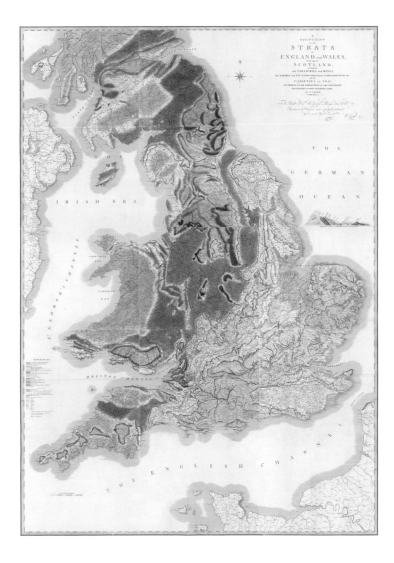

Fig. 2. William Smith,
*A Delineation of the Strata of
England and Wales, with Part
of Scotland*, 1815, engraving
and etching with gouache,
Geological Society of London,
LDGSL/22. Reproduced by
permission of the Geological
Society of London

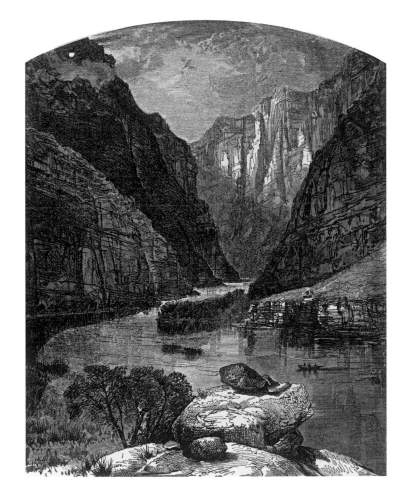

Fig. 3. E. Bookhout after
Thomas Moran, *Gate of
Lodore*, wood engraving,
fig. 8 in *Exploration of
the Colorado River of the
West and Its Tributaries*,
Washington, 1875, Vassar
College Libraries

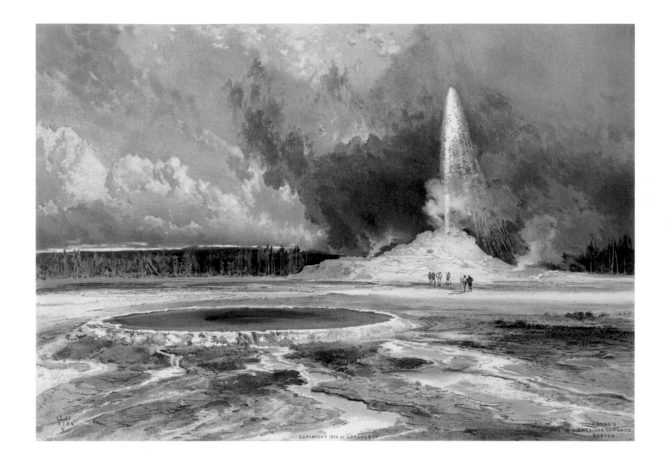

Museum) is much better known, Moran's chromolithograph from plein-air sketches of Castle Geyser in the Upper Geyser Basin is striking and captures the spectacle of steaming water spouting from beneath the earth's surface (fig. 4). Moran wrote about painting landscapes, "I have to have knowledge. I must know the geology. I must know the rocks and the trees and the atmosphere and the mountain torrents...."[12] Moran's chromolithograph of Castle Geyser reveals such knowledge. So too does his drawing *Back of the South Dome from the Nevada Trail, Yosemite* (cat. 39), which accurately depicts the rounded mountain profiles derived from the weathered granite of which they are made.

Moran's color print of the astounding geothermal features must have awed Albert Bierstadt, too, because Upper Geyser Basin became Bierstadt's studio and Castle Geyser his subject (cat. 38). Bierstadt's oil study in the exhibition reveals the wonder of a geyser erupting and incorporates

with precision those elements that field geologists would include in a geological report about the Basin, such as mineral deposits that form the geyser's edifice.

Castle Geyser built steadily over thousands of years by precipitation from superheated water from the geyser's vent. With an eruptive event that lasted approximately one hour occurring roughly twice a day, the geyser would have been simultaneously a steady yet fabulously dynamic phenomenon to portray. In the foreground of Bierstadt's study the viewer sees Crested Pool, a hot spring. Bierstadt shows the rich blue color that results when a pool is deep, for as depth increases water absorbs red wavelengths of visible light and reflects blue. Bierstadt has caught also the lighter blue near the rim of Crested Pool that appears in shallower waters near the hot spring. Finally, Bierstadt noted the orange hues resulting from the presence of what are known today to be "extremophiles"—cyanobacteria that can survive in the

presence of excessive heat. The only questionable feature of this oil study from a geologist's point of view is the stillness of the water in Crested Pool reflecting the eruption of Castle Geyser and the trees that witness the phenomenon. Because of the high water temperature, Crested Pool would likely have been boiling steadily and therefore would not have mirrored the geyser and trees in still waters.

American artists Moran and Bierstadt were enthralled by the steaming vents and bubbling pools of Yellowstone during the second half of the nineteenth century. Earlier in that period, explorer, topographer, painter, and member of the Irish gentry, Isaac Weld produced a watercolor of Vesuvius in eruption (cat. 35)—the iconic structure that looms over modern Naples and owes its existence to the kind of volcanic activity that produces the cauldron of Yellowstone. During Weld's time, Britons of "good breeding" undertook the "Grand Tour" of European cultural centers as an essential part of a gentleman's education, and Naples, as one of the customary stops, would have afforded a bird's-eye view of Vesuvius, famed for having erupted throughout much of the eighteenth century. Weld's watercolor does justice to the volcanic features that Pliny the Younger refers to in two famous letters to the historian Tacitus:

> broad sheets of fire and leaping flames blazed at several points, their bright glare emphasized by the darkness of night…. [By the time there was daylight they were] still in darkness, blacker and denser than any ordinary night…. dense black cloud was coming up behind us, spreading over the earth like a flood.[13]

In the watercolor, incandescent lava flows and fountains forming luminous arcs in the sky, billowing plumes of ashy gasses, and clouds of pyroclastic material, compose in visual language both an artistic and geological study of volcanic activity.

Volcanoes figured prominently in nineteenth-century debates between "catastrophists" and "uniformitarians." Catastrophists, Swiss geologist Louis Agassiz (1807–1873) foremost among them, argued that most geological change occurred in rare episodes of global paroxysm marked by volcanism, earthquakes, and flooding. In contrast, Charles Lyell (1797–1875), primary architect of the contrasting uniformitarian view and author of *Principles of Geology* (1830–33)—one of the most important scientific textbooks ever written—and others in his camp held that the Earth was in constant motion changing only in small and regular steps. Vesuvius was the volcano that exemplified catastrophism. But Alfred Diston's *The Peake of Tenerife* (cat. 41) and Frederic Church's *Mount Chimborazo at Sunset* (cat. 40) were also painted as this critical debate churned about the nature of Earth's state and its pace of change. All three works of art are vivid and authentic illustrations of stratovolcanoes, which feature conical, rather than broad, profiles. They also serve as symbols of Earth's awesome power, reflecting Church's conviction, via Humboldt, that scientific accuracy is necessary in order to depict meaning and beauty in nature.

Thomas Rowlandson's (1757–1827) *Giant's Causeway, Antrim, Ireland* (cat. 10) also depicts a volcanic feature, though a less obvious one. Much like the Palisades along the Hudson River, to which Charles Lyell referred at a lecture in New York in 1840, the rocks of the Giant's Causeway are columnar basalts formed when highly molten magma was injected, cooled, and contracted between sedimentary

layers rather than having been erupted on the Earth's surface. Appearing as the pipes of a gigantic organ, the columns serve as pedestals for the figures visible in the scene. The watercolor conveys the massive scale of geological phenomenon.

Humboldt placed landscape painting among the highest expressions of the love of nature.[14] Landscape paintings of the eighteenth and nineteenth centuries reflect that view. Equally, for geologists such as I, observation and interpretation of geological formations are a means to express devotion to something greater than myself. I venture to guess that most geologists would object to art critic John Ruskin's (1819-1900) view that "the man who has gone, hammer in hand, over the surface of a romantic country, feels no longer, in the mountain ranges he has so laboriously explored, the sublimity or mystery with which they were veiled when he first beheld them...."[15] Though geologists certainly view landscapes with a scientific eye, manifestations of our visual language often reflect a sense of the sublime as well as the stillness and silence of vast landscapes. I would like to think that geologists regard the Earth with something of an artist's eye and that artists scrutinize landscapes with a geological gaze while sharing a sense of awe expressed in the landscapes of this exhibition.

*

I thank Patricia Phagan for identifying the various processes used in the works of art that are referenced here.

1. Hugh Miller, *Landscape Geology: A Plea for the Study of Geology by Landscape-Painters* (Edinburgh and London: William Blackwood and Sons, 1891), 50; and N. P. C., "Sketchings: Relation Between Geology and Landscape Painting," *The Crayon* VI (August 1859): 256.
2. Martin Rudwick, "The Emergence of a Visual Language for Geological Science 1760-1840," *History of Science* 14, no. 3 (1976): 149; and Matthew N. Johnston, *Narrating the Landscape: Print Culture and American Expansion in the Nineteenth Century* (Norman: University of Oklahoma, 2016), 6, 7, 12.
3. Miller, *Landscape Geology*, 6-7.
4. Rudwick, "The Emergence of a Visual Language," 149.
5. James Hutton, *Theory of the Earth* (1795), online ed., Library of Alexandria, n.p. The well-known saying is published earlier in James Hutton, "Theory of the Earth: Or an Investigation of the Laws Observable in the Composition, Dissolution, and Restoration of Land upon the Globe," *Transactions of the Royal Society of Edinburgh* I (1788): 304.
6. G. Y. Craig, D. B. McIntyre, and C. D. Waterston, *James Hutton's Theory of the Earth: The Lost Drawings* (Edinburgh: Scottish Academic Press; Edinburgh: Royal Society of Edinburgh; London: Geological Society of London, 1978).
7. Martin Rudwick, review of *James Hutton's Theory of the Earth: The Lost Drawings*, by G. Y. Craig, D. B. McIntyre, and C. D. Waterson, *British Journal for the History of Science* 13, no. 1 (March 1980): 83.
8. Hans Cloos, *Conversation with the Earth* (New York: A. A. Knopf, 1953), 28.
9. Barbara Novak, *Nature and Culture: American Landscape and Painting, 1825-1875*, 3rd ed. (New York and Oxford: Oxford University Press, 2007), 61.
10. Elizabeth C. Childs, "Time's Profile: John Wesley Powell, Art, and Geology at the Grand Canyon," *American Art* 10, no. 1 (Spring 1996): 6.
11. Johnston, *Narrating the Landscape*, 167.
12. Thomas Moran, "Knowledge a Prime Requisite in Art," *Brush and Pencil* 12, no. 1 (April 1903): 14.
13. Betty Radice, trans., "Letters 6.16 and 6.20," *The Letters of Pliny the Younger* (Harmondsworth: Penguin Books, 1963), 163.
14. Novak, *Nature and Culture*, 3rd ed., 60-61.
15. John Ruskin, *Pre-Raphaelitism* (New York: John Wiley, 1851), 56.

Frederic Church
Cliffs and Rocky Cove, Mount Desert Island
ca. August 1850
Oil on light brown cardboard
Large detail of cat. 50

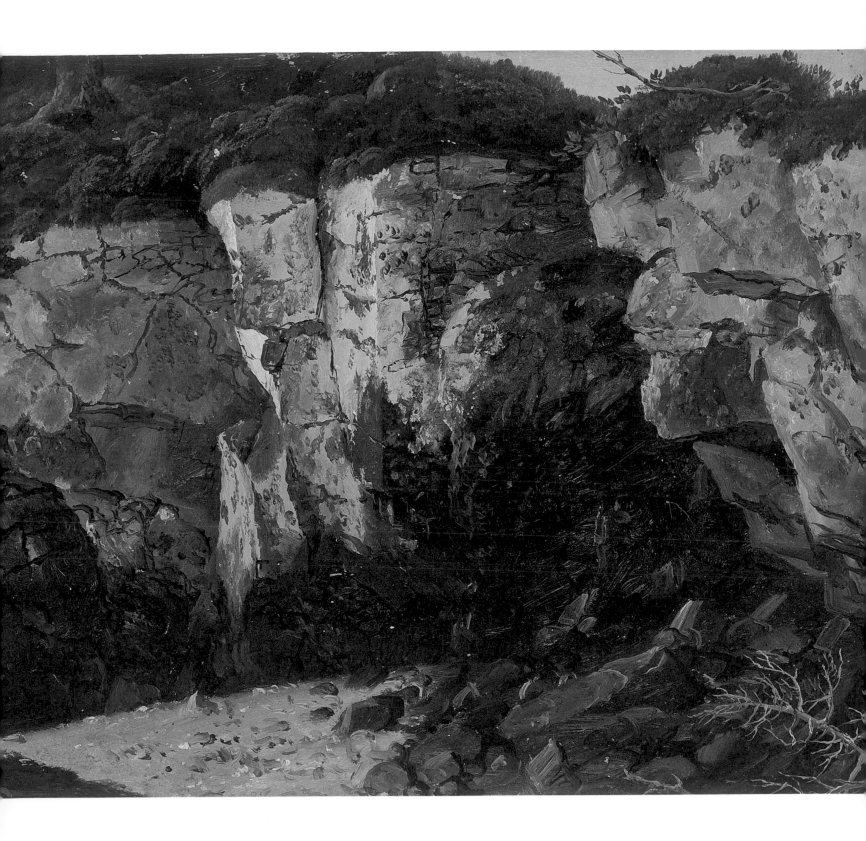

CATALOGUE

1

JOSEPH WRIGHT OF DERBY
(British 1734–1797)

Entrance to the Dove Holes, Derbyshire 1773

Brush and gray and black wash over touches of graphite on cream laid paper
13½ × 20¾ in. (34.3 × 52.7 cm)
Princeton University Art Museum, Museum Purchase, Surdna Fund
and Fowler McCormick, Class of 1921, Fund
2009-24
Photo Credit: Princeton University Art Museum / Art Resource, NY

Images of rugged rocks and cliffs enliven Joseph Wright's early portraits
of residents from his hometown of Derby. By the late 1760s and early
1770s, as his interest in landscape evolved and became more complex, so
apparently did his engagement with natural science. In 1773 he rendered
this large, careful drawing of an immense, sunbaked wall of layered,
blocky sedimentary rock cut through with an exaggerated swirl of ink
and wash for the mouth of a cave. The work features one of two shallow
caves called Dove Holes, in Dovedale in the verdant English Midlands,
which is famously studded with Carboniferous limestone formations.

Wright shared interests in the geology of Derbyshire with his
neighbor and friend John Whitehurst (1713–1788). A member of the
progressive Lunar Society of Birmingham, Whitehurst was a clock- and
instrument-maker drawn to the study of fossils, rocks, minerals, and
theories on earth's beginnings.[1] His excursions into caves in Derbyshire
and his own geological theories led to the book *Inquiry into the Original
State and Formation of the Earth*. First published in London in 1778 but in
development for several years, the illustrated work supported the notion
of the Old Testament Flood, yet in pioneering fashion posited for the first
time the idea of a system of stratification, or layering, in the earth's crust.[2]

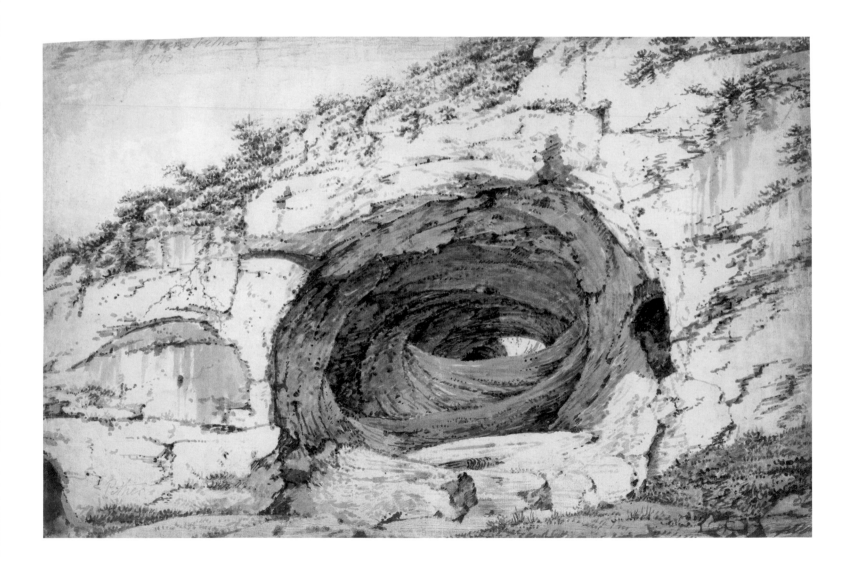

2

JOHANN CHRISTIAN REINHART
(German 1761–1847)

Rocky Landscape with Hunters 1786

Pen and brown ink, brush and brown and gray wash, and graphite on cream laid paper;
framing line in black ink
15¹⁄₁₆ × 18¾ in. (38.2 × 47.6 cm)
The Metropolitan Museum of Art, Gift of Katrin Henkel, 2003
2003.405
Image copyright © The Metropolitan Museum of Art
Image source: Art Resource, NY

The classically inspired painter and topographer Johann Christian Reinhart
belonged to the colony of German artists in Rome in the late eighteenth and
early nineteenth centuries who rendered careful observations of natural features.
Earlier drawings by Reinhart also show this interest, however, especially after
his move to Dresden in 1783. There he joined the circle of artists around Johann
Christian Klengel (1751–1824), with whom he took private lessons, and Adrian
Zingg (1734–1816), the latter known for his countryside excursions and wash
drawings picturing rocky terrain.[3]

 Inspired by Zingg's example, Reinhart and artist Konrad Gessner (1764–1826)
traveled together to draw and paint after nature.[4] In 1786 Reinhart made
this drawing of a forbidding cave entrance near the village of Muggendorf in
Franconian Switzerland, Bavaria, part of the Jura upland in Germany. Reinhart
apparently drew it lightly and finished it at Leipzig, as it is inscribed "Reinhart
fec. 1786./a Leipsic.," where he had studied theology and art and was living
again.[5] Ostensibly a narrative scene, the subject is the multi-layered, toothy
limestone entrance, which resembles the northern mouth of the Oswaldhöhle,
though he opened up its upper masses. The cave is one of several in the
Muggendorf area with their natural histories first published in 1774 in a book
by Johann Friedrich Esper (1732–1781). Esper noted the caves' fossil bones, and
believed a Deluge formed the area's mountains and caverns and affected the
entire earth long ago.[6]

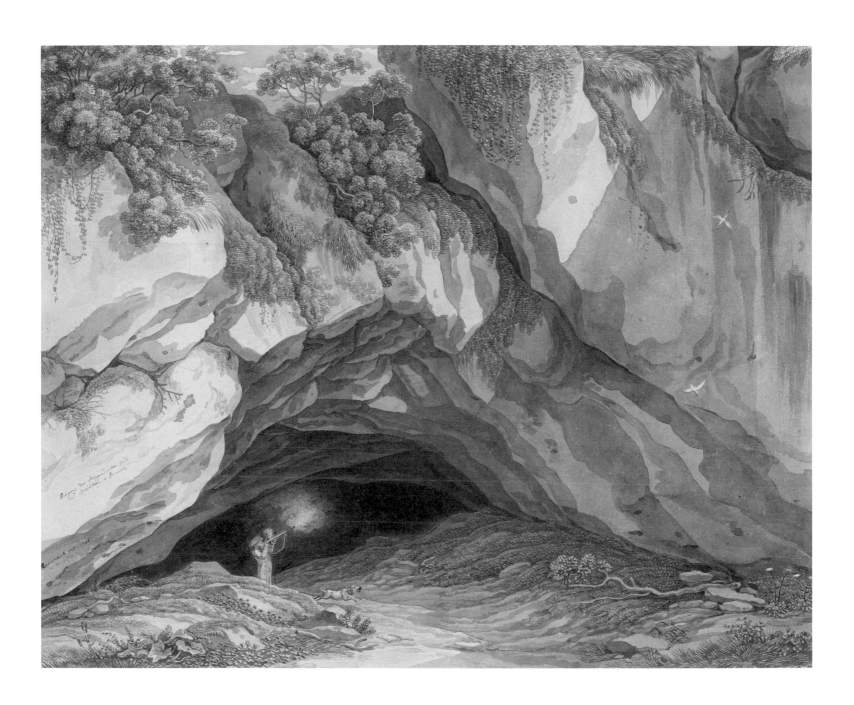

3

CLAUDE BONNEFOND
(French 1796–1860)

Ravine at Sorrento 1824

Oil on paper, laid down on canvas
10⅝ × 14⅜ in. (27 × 36.5 cm)
The Metropolitan Museum of Art, Thaw Collection, Jointly Owned by The Metropolitan
Museum of Art and The Morgan Library & Museum, Gift of Eugene V. Thaw, 2009
2009.400.11
Image copyright © The Metropolitan Museum of Art
Image source: Art Resource, NY

Lyon artist and Salon genre painter Claude Bonnefond rendered this focused detail of a cavity-riddled ravine at Sorrento on his first visit to Italy, arriving toward the end of 1824. There, where he sketched and made studies *en plein air* for over a year, he became part of the community of French artists.[7] The site is likely the dramatically deep ravine that cuts close to the center of this town located on the southern shore of the Bay of Naples. The community was built on volcanic tuff from the Campanian ignimbrite eruption, a volcanic pyroclastic flow deposited around thirty thousand years ago around Naples, across the bay.[8]

A favorite site to visit and paint among French artists and others in the early nineteenth century, the ravine and its unusual tuff walls, or *tufa*, as it was called by the locals in the region, attracted Bonnefond during this first visit. Later, in 1831, he returned home to become the director of the École des Beaux-Arts de Lyon. Rising from a strong tradition of *sur-le-vif* painting around Rome and Naples in the late eighteenth and early nineteenth centuries, the sketch reveals sunlight showering the ravine floor and eroded volcanic walls, with a heavy emphasis on the earth-changing activity of nature.

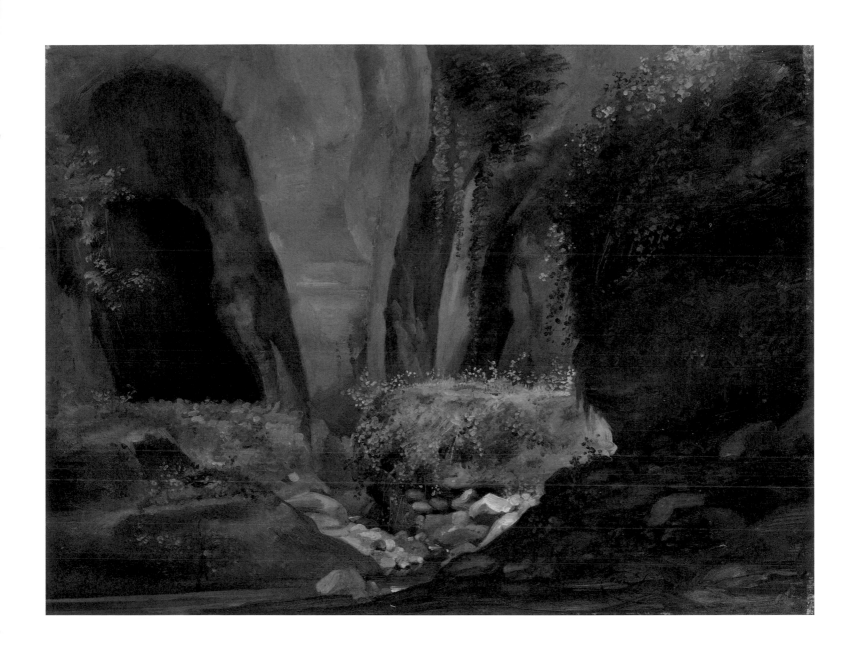

4

ASHER BROWN DURAND
(American 1796–1886)

"Dover Stone Church," Dover Plains, New York ca. 1847

Graphite and white gouache on gray paper, mounted on card
14 × 10 in. (35.6 × 25.4 cm)
The New-York Historical Society, Gift of Miss Nora Durand Woodman
1918.125
Photography © New-York Historical Society
(Vassar only)

"Dover Stone Church," a cave located in the hills west of the village of Dover
Plains, New York, garnered Asher B. Durand's attention when on a sketching
trip, perhaps around 1847.[9] The village was named after the chalk cliffs of Dover,
England, because of marble outcroppings in the area. Found around twenty-
three miles east of Poughkeepsie, the cave has an arch-like entrance created
by a jagged fissure, which lent itself to the idea of a church steeple. Durand
concentrated on the two gigantic walls of carefully drawn strata that converge
at the fissure and overwhelm and form the entrance. The rocks rest in layers one
upon another tightly or precariously, and some lay at the entrance.[10]

The drawing demonstrates Durand's attention to geological subjects in
the 1840s, especially caves, where fossils were often discovered. He had shown
this interest the decade before with a sketch of conchologists that was praised
by his mentor Thomas Cole, a geology enthusiast and hiking companion.[11]
In the eighteenth century in Europe, the study and collecting of fossil shells
had thrived. In the early nineteenth century, geologists studied them for their
association with various strata in the earth's crust, leading to conclusions about
episodes in the earth's past.

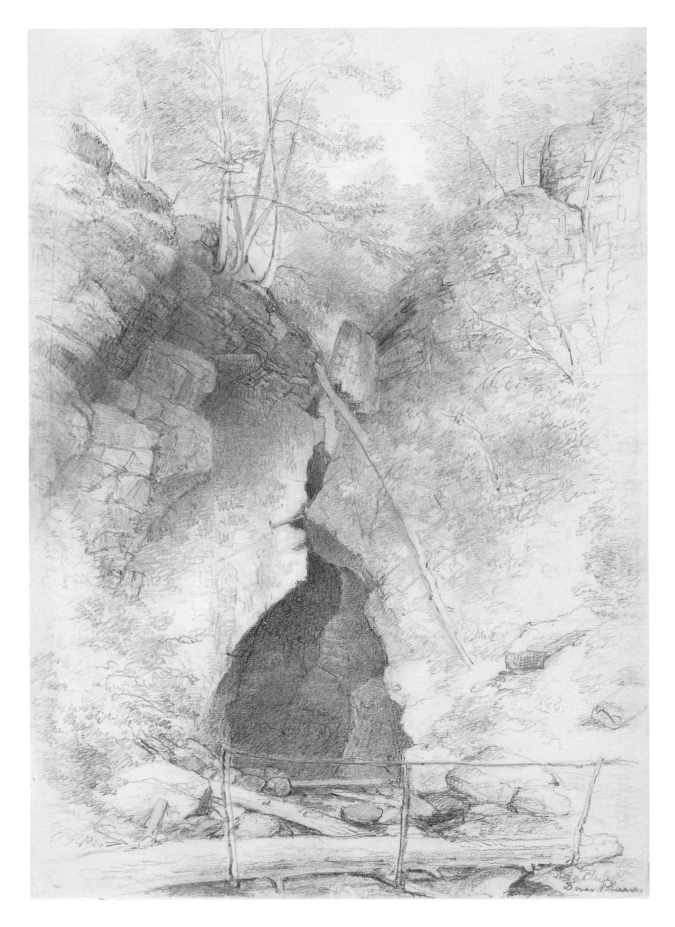

5

JOHN WEBBER
(British 1751-1793)

View from Renard's Hole, Dovedale, Derbyshire 1789

Graphite and gray wash on medium, slightly
textured, cream laid paper
10 × 12¾ in. (25.4 × 32.4 cm) (sheet)
Yale Center for British Art, Paul Mellon Collection
B1977.14.5771

6

WILLIAM DAY
(British 1764-1807)

Renard's Hole, Dovedale, Derbyshire 1789

Watercolor, pen and brown ink, black ink, gray ink and graphite
on moderately thick, moderately textured, cream laid paper
13¼ × 14⅞ in. (33.7 × 37.8 cm) (sheet)
Yale Center for British Art, Paul Mellon Collection
B1975.4.1495

London artist John Webber was reared with relatives in Bern, the Swiss city that
rests on a plateau between the Jura Mountains and the Bernese Alps. Beginning
in 1767 he studied there for three years with Johann Ludwig Aberli (1723–1786),
a prominent topographical watercolorist. Afterwards he trained with German
artist Jean-Georges Wille (1715–1808) in Paris, and attended the Académie
Royale. The two made sketching tours together in 1773 and 1774. Returning to
London in 1775, he entered the Royal Academy Schools.[12]

In 1776 Webber joined the third voyage to the Pacific of Captain James Cook
(1728–1779) as artist. He also made sketching trips into Britain and continental
Europe, observing interesting natural features.[13] In summer 1789 Webber
visited Derbyshire with London linen draper and amateur geologist William
Day. Both drew on the spot and filled in with wash or watercolor, working in a
topographical approach and often rendering the same motif. In Dovedale they
recorded Reynard's Hole, a limestone attraction carved in 325 million-year-old
Carboniferous-aged rocks that formed from the accumulation of fossilized
fragments of marine organisms.[14] Tellingly, Day's more scientific eye emphasized
the clashing of stratigraphic layers. His attention to such detail and his collecting
of minerals confirm an avid interest in natural history.[15]

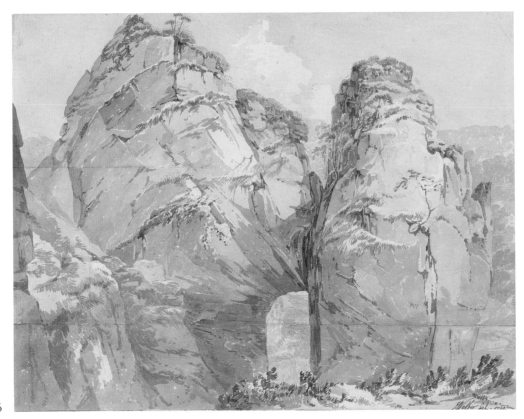

5

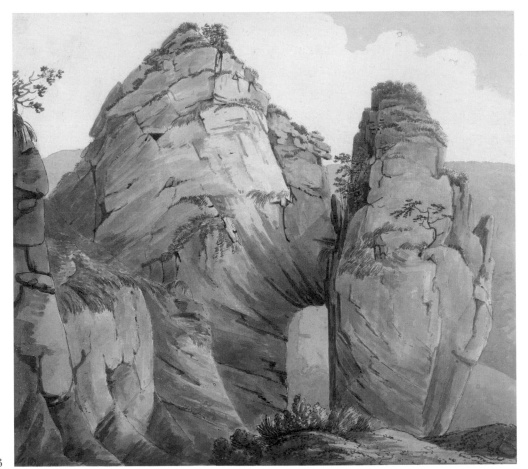

6

7

JASPER FRANCIS CROPSEY
(American 1823–1900)

Arched Rock, Capri 1848

Watercolor and graphite on paper
8¹³⁄₁₆ × 11⅜ in. (22.3 × 28.9 cm) (sheet)
Museum of Fine Arts, Boston, Gift of Maxim Karolik for the M. and M. Karolik
Collection of American Watercolors and Drawings, 1800–1875
54.1627
Photograph © 2018 Museum of Fine Arts, Boston

The Hudson River landscape painter Jasper Cropsey made his first trip to Italy in 1847–49, where for a period of time he stayed in Thomas Cole's former studio in Rome. In 1848 he visited Amalfi, Capri, and Paestum, among other celebrated locations south of Naples, and lived in a villa for a few months at Sorrento with some fellow artists. He made this sketch of the spectacular natural arch at Capri on July 20th, as inscribed, with watercolor perhaps added a bit later. The arch appears to be an eroded remnant of a cave on this island made of Apennine limestone.[16] Christopher Pearse Cranch, who accompanied Cropsey, noted that they visited the major attractions on the island, including the Ponte Naturale, "a grand and wonderful arch of gray rock on a high cliff near the sea, the Grotto Matrimonia, the Piccola Marina, the Blue Grotto again, and Anacapri.... We made a good many sketches in pencil...." In August, on another trip, Cropsey and Cranch found the fantastic formations they encountered in the Gulf of Salerno particularly appealing.[17]

The trip to Italy reinforced Cropsey's already strong attention to the rocky landscape, a focus that he had shown in his drawings and plein-air oil sketches in the U.S. by the mid-1840s. Elected an associate of the National Academy of Design in New York in 1844, he had begun visiting the Catskills and drawing wild, rocky landscapes, documenting them with pencil outlines like Thomas Cole and other Hudson River School artists. The journey in Italy capped Cropsey's early and deep engagement with geological themes *en plein air* stimulated by his knowledge and admiration of Cole.

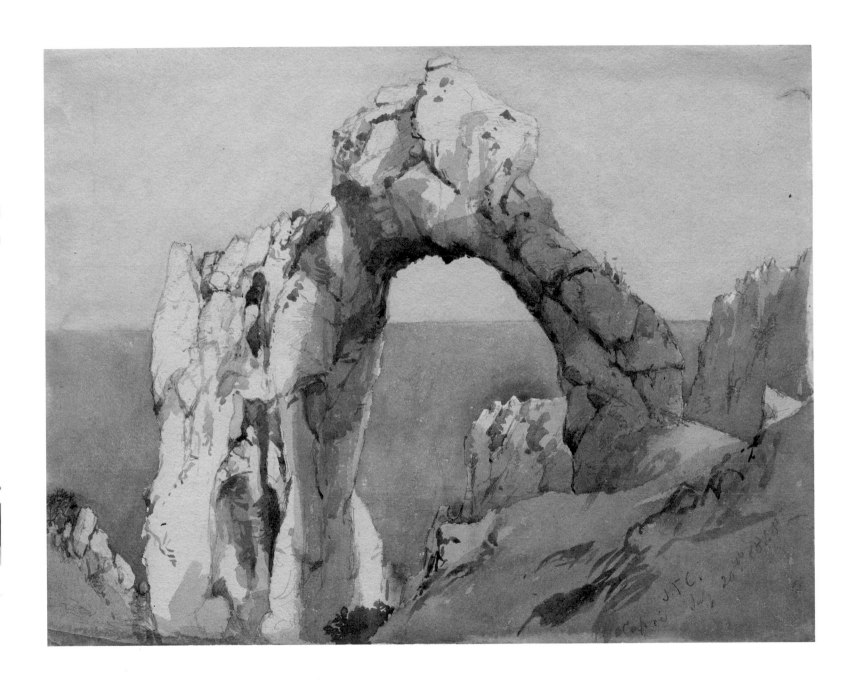

8

WILLIAM TROST RICHARDS
(American 1833–1905)

Dorset Coast, from Sketchbook 1879

Watercolor and white chalk over graphite on blue wove paper
7¾ × 10½ in. (19.6 × 26.6 cm) (open sketchbook)
The Morgan Library & Museum, Purchased as the gift of Mrs. John Hay Whitney
1997.2

The American Pre-Raphaelite painter William Trost Richards made close observations of the natural world and its atmospheric conditions, plant life, and outer layers of rocks. The Philadelphia-born artist sketched early on in the Hudson River School landscape method of topographical outlines and selected details, choosing sites in the Hudson Valley favored by artists in this first American painting movement.[18] Their interest in geology evidently was transmitted to Richards, who by 1854 noted, "I have long been wishing to study in an Elementary Manner Geology. ...I must make it part of my discipline for the winter."[19]

Mineralogy and geology had for decades been popular in Germany, and the crisp delineation of the rocky landscape became a hallmark of the Düsseldorf Academy. Richards's training with German painter Paul Weber (1823–1916) prepared him for a two-month stay in Düsseldorf while on a Grand Tour of 1855–56.[20] The school attracted American artists favoring the meticulous style practiced there. Afterwards, Richards turned more of his attention to geological structure through minute focus on the earth's surfaces, fissures, and layers. He renewed this enthusiasm in the next decade through his admiration for the British Pre-Raphaelite painters and by joining the Association for the Advancement of the Cause of Truth in Art, the American Pre-Raphaelite group devoted to Ruskin's truth-to-nature mandate.[21] By the late 1870s, with changing tastes in landscape, Richards had swung much of his artistic focus to coastal scenes. In summer 1879, on an excursion to the Dorset Coast in southern England, he filled a sketchbook with drawings, including this watercolor of what is probably Durdle Door, a limestone natural arch featured at Lulworth Cove.

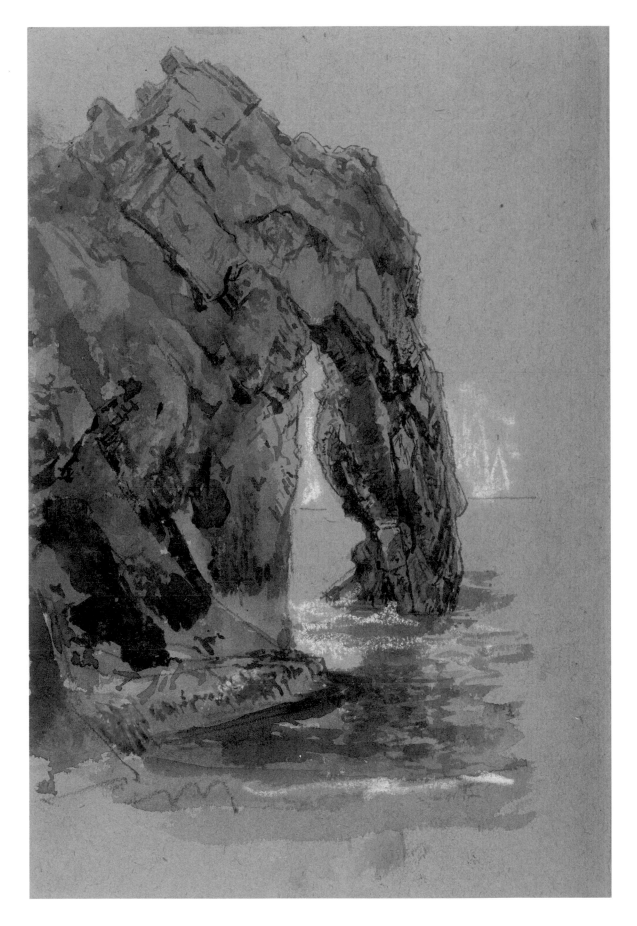

9

JOHN BRETT
(British 1830–1902)

Kynance 1888

Oil on canvas
7 × 14⅛ in. (17.8 × 35.9 cm)
The Metropolitan Museum of Art
Bequest of Theodore Rousseau Jr., 1973
1974.289.2
Image copyright © The Metropolitan Museum of Art
Image source: Art Resource, NY

British landscape artist John Brett showed a keen interest in geology. As
a young painter, he was impressed with the ideas found in the geology-
infused first volume of Ruskin's *Modern Painters* (1843), and he esteemed
the Pre-Raphaelite painters and their deliberate approach to rendering
nature.[22] A sojourn in the Bavarian Alps provided the impetus for him
to delve into detailed geological observation, resulting in his *Glacier of
Rosenlaui* (1856, Tate, London), a roiling sea of ice and rocks painted on
the spot. Brett had been inspired by watching John William Inchbold
execute his lifelike painting of the Jungfrau, which was rendered "with
knowledge, skill, and research," according to a contemporary critic.[23]

In this much later oil sketch, coagulated paint mimics the surface
and colors of rocks at Kynance Cove on the coast of Cornwall, England.
Painted on site in September 1888, Brett had traveled there to make
sketches in preparation for a commissioned painting, *The Lion, the Lizard
and the Stags*.[24] Brett's densely painted rocks appear to depict the unusual,
distinctive, and rare red and green serpentinite rocks that make up the cliffs
found there.[25] The two formations on the left were probably at one time a
natural arch that eroded with the repeated forces of water and wind.[26]

10

THOMAS ROWLANDSON
(British 1757–1827)

Giant's Causeway, Antrim, Ireland

Watercolor with pen and red-gray and gray ink, over graphite
on medium, moderately textured, beige, wove paper
5¾ × 9⁵⁄₁₆ in. (14.6 × 23.7 cm) (sheet)
Yale Center for British Art, Paul Mellon Collection
B1977.14.5574

So accessible was geology in Britain in the early nineteenth century that the
well-known social and political satirist Thomas Rowlandson sought to render
a prominent geological site. Drawing in a loose topographical style of pen and
ink outline and watercolor washes, Rowlandson made this view of the Giant's
Causeway, located in Antrim, Northern Ireland. The causeway landscape is
crowded with stands of basalt columns, beyond which lie the sea and a succession
of headlands. Rowlandson does not appear to have traveled to Ireland, and
his watercolor closely follows an aquatint of the Giant's Causeway featured in
Interesting Selections from Animated Nature, with Illustrative Scenery, a print series
designed and engraved by William Daniell (1769–1837) of 1807–1809.[1]

 Rowlandson's interest in geological formations can be seen in 1784 with his
first visit to the Isle of Wight off the southern coast of England. His friendship
with banker and art patron Mathew Michell (1751–1817) spurred visits by the
artist from the 1790s on to Michell's rural estate and property in the county
of Cornwall on the far southwestern coast.[2] The artist showed much interest
there in geological features at Tintagel, Bodmin Moor, and Roche Rock. In the
1790s he made excursions to the Isle of Wight again and executed watercolor
landscapes of the island that included subjects such as ravines, striated cliffs,
and caves.[3]

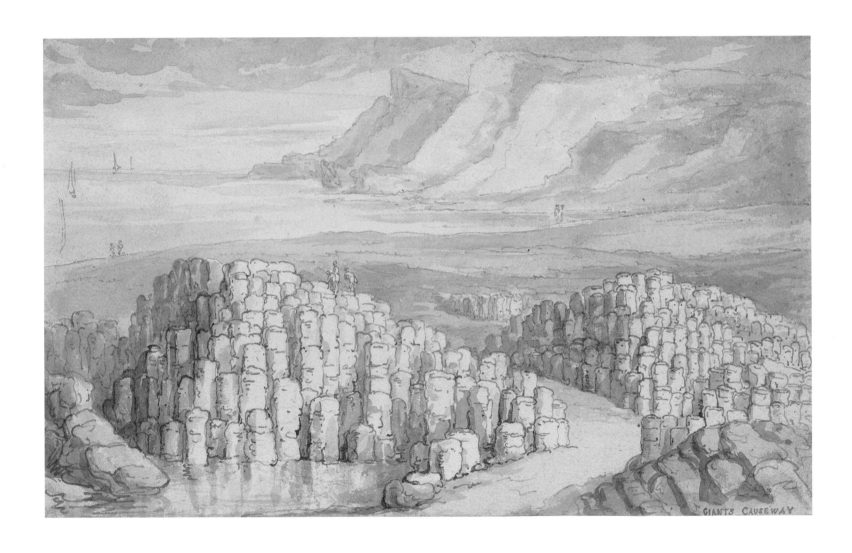

GIANTS CAUSEWAY

11

THOMAS JONES
(British 1742–1803, active in Italy, 1776–1783)

Study of Rocks, near Pencerrig, Wales 1796

Watercolor on medium, moderately textured, cream laid paper
6¼ × 8 in. (15.9 × 20.3 cm) (sheet)
Yale Center for British Art, Paul Mellon Collection
B1977.14.4665

Welsh artist Thomas Jones meticulously eyed the granular building blocks of the earth in his oil studies, drawings, and watercolors made on the spot after nature.[4] An avid memoirist with an eye for geological detail, he frequently recalled specific rocks, including the "dark grey Lava of Mount *Vesuvius*" or "that friable, cream Colord Stone about Naples, calle'd *Tuffa*." He familiarized himself with local natural history and geology, citing the Albano and Nemi lakes in Italy as "immense inverted Cones" that had "cast forth" the hills around them.[5]

After study in London with landscape painter Richard Wilson and a Grand Tour and residence of several years in Italy, Jones returned home in the 1780s to the county of Radnor to tend the family's estate, Pencerrig. The area lay under the sea during the Cambrian, Ordovician, and Silurian periods, and its mud turned eventually into sandstone, slate, and shale.[6] By 1820, a writer commented on a quarry near "Pen Cerig," describing its abundance of volcanic greenstone basalt and slate.[7]

Experiencing the rocky land around Pencerrig during his youth may have informed Jones's lifelong habit of looking closely at the earth. In this unconventional watercolor of land near the estate, Jones pictured prismatic, basalt-like rocks jostling one another, perhaps at the nearby quarry. He made the watercolor in 1796 during his retirement.

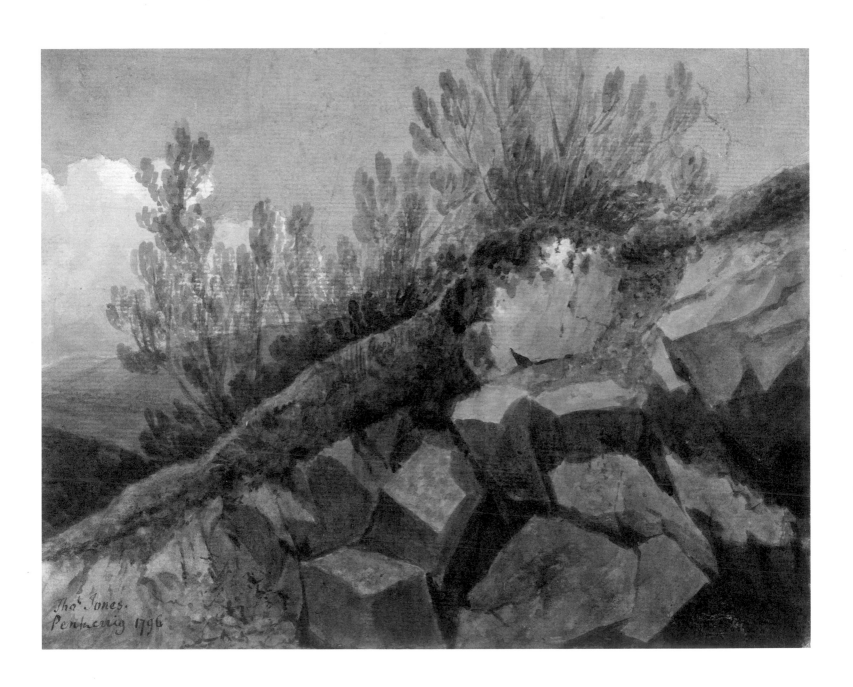

12

JOHN RUSKIN
(British 1819–1900)

Study of Boulders

Brown and gray wash and graphite on heavy cream paper
7 11/16 × 13 3/8 in. (19.7 × 34.2 cm) (sheet)
The Morgan Library & Museum
1974.49.284

A member of the Geological Society of London, John Ruskin showed a deep interest in geology during much of his life. As a young boy he read natural history and geology books, and at ten he began a mineral collection. Later he was writing a mineralogy dictionary and seeing the natural history collections at the British Museum.[8] At the age of fifteen, when the new science of geology was reaching celebrity status in Britain, Ruskin contributed an article to Loudon's *Magazine of Natural History*. Having visited and made sketches the year before in the Alps, he wrote in his short illustrated article about the dark red granite and layers of rock and alluvium of Mont Blanc and neighboring mountains. Prints after his topographical drawings of aiguilles and his geological section drawing accompanied the article.[9]

At Oxford University, Ruskin made diagrams for lectures by William Buckland (1784–1856), a leading geologist. Ruskin furthered his new scientific interest with excursions to Scotland and more trips to the Continent, and a growing passion for the generative power and geology of nature, inspired by the work of J. M. W. Turner (cat. 27). Further trips to Scotland seemed to revitalize Ruskin's great interest in rocks, which was cemented with his master drawings *Study of Gneiss Rock, Glenfinlas* (1853, Ashmolean Museum, Oxford) and *Fragment of the Alps* (1854, Harvard University Art Museums) and his study of mountain-building published in the fourth volume of *Modern Painters* (1856).[10] Ruskin made numerous drawings of individual rocks and outcrops. In this undated one, free-flowing waters run between misshapen and puckered rocks, in a demonstration of form-changing erosion taking place over time.

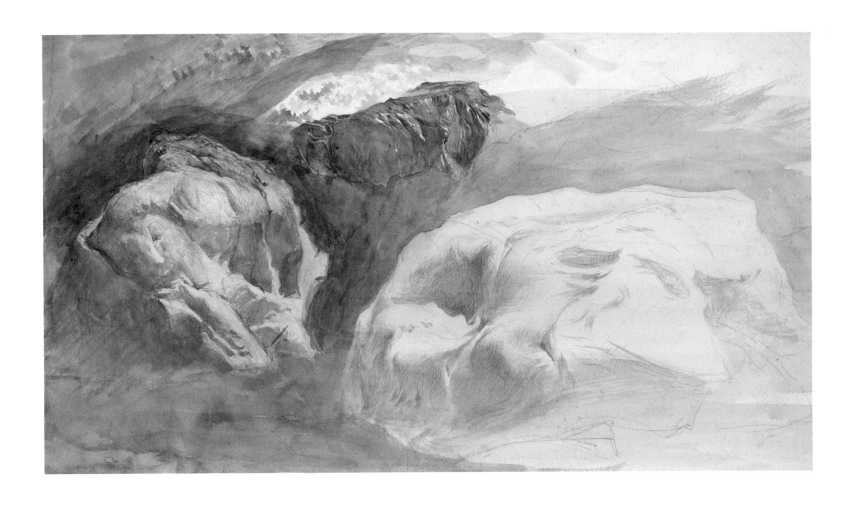

13

JOSEPH NOEL PATON
(British 1821–1901)

Study from Nature: Inveruglas 1857

Watercolor heightened with gouache on moderately thick, moderately textured,
cream wove paper
14½ × 20½ in. (36.8 × 52.1 cm) (sheet)
Yale Center for British Art, Friends of British Art Fund and Mr. and Mrs. Bart T. Tiernan,
LLB '68, with additional support from: Mr. and Mrs. Ronald R. Atkins; Elizabeth Ballantine,
BA '71, MA '74, MSL '82, PhD '86; Mr. and Mrs. Henry E. Bartels; The Ajax Foundation
on behalf of Mr. and Mrs. Richard Bressler; Bruce Budd; Homer Byington, III, BA '56;
Mr. and Mrs. Norman C. Cross, Jr.; Lee MacCormick Edwards; The Forbes Foundation;
Mr. and Mrs. Brian Hopkinson; Mr. and Mrs. Thomas Israel, BA '66; Katherine Haskins;
Mr. and Mrs. Lowell Libson; Mr. and Mrs. Robert A. Martin, BA '54; Virginia Mattern;
Mona Pierpaoli and David Adler; and Mr. and Mrs. Ross D. Siragusa, Jr., BA '53
B2008.20
(Vassar only)

A follower of John Ruskin, the Scottish artist Joseph Noel Paton painted
allegorical fantasies, naturalistic landscapes, and history and religious subjects.
He trained at the Royal Academy Schools, meeting there his good friend John
Everett Millais (1829–1896), the Pre-Raphaelite painter inspired by Ruskin and
his truth-to-nature art theories. Living mostly in Scotland, Paton knew about the
lectures Ruskin gave in Edinburgh in 1853. Though he reportedly did not attend,
he heard from a friend about the talks, wherein Ruskin gave his full support to
Pre-Raphaelitism, which he declared "has but one principle, that of absolute,
uncompromising truth in all that it does, obtained by working everything, down
to the most minute detail, from nature."[11]

During the 1850s Paton painted nature in a precise and profuse Pre-Raphaelite
approach. He rendered this watercolor of the wilds and metamorphic rocks
of Inveruglas, a small village along Loch Lomond in Scotland. Dated August
21, 1857, the on-the-spot watercolor exudes the Ruskinian interest in striking
geological and botanical detail and in the force of water that shapes the earth's
hard, outer layers of rocks.

14

ALPHONSE NICOLAS-MICHEL MANDEVARE
(French ca. 1770–ca. 1850)

Study of a Rock Outcropping (with bushes at left) ca. 1820–25

Black chalk on cream laid paper
17¹⁵⁄₁₆ × 24⅛ in. (45.5 × 61.3 cm) (sheet)
Museum of Fine Arts, Boston, Lucy Dalbiac Luard Fund
2000.765
Photograph © 2018 Museum of Fine Arts, Boston

The freely drawn, large chalk study of a fantastic-shaped rock with plants clinging to it by the neo-classical artist Alphonse Nicolas-Michel Mandevare presents what could be a glacial erratic—a large boulder transported by ice far from its place of origin. Many of these were left by advancing glaciers and were the subject of much curiosity and theoretical discussion in the late eighteenth century and beginning of the nineteenth century in Europe and the United States.

Active in Paris during these years, Mandevare showed his landscape drawings regularly at the Salon for decades.[12] In his landscape treatise from 1804, *Principes raisonnés du paysage*, he followed academic practice and prescribed that art students first learn to draw landscape by going out into nature, with materials in hand, rendering the outline, tone, and texture of individual components. Importantly, he championed the idea of seizing on paper their particular character, an Enlightenment concern with the close study of nature. For example, he advised against losing a rock's individual traits when one rendered it, noting that rocks were generally angular.[13]

15

JOSEPH WRIGHT OF DERBY
(British 1734–1797)

Study of Rocks and Trees 1774 or 1775

Graphite, ink, and gray wash on cream laid paper with watermark
(similar to Briquet 7207 and 7210)
14¹⁵⁄₁₆ × 21³⁄₈ in. (37.94 × 54.29 cm) (sheet)
Frances Lehman Loeb Art Center, Vassar College
Purchase, Suzette Morton Davidson, class of 1934, Fund
1966.23.9

Geological features were major landscape interests for Joseph Wright of Derby
at a time when theories on the creation of the earth proliferated. Perhaps he was
curious about the age and origins of these two exposed, ancient, and eroded
boulders and how they arrived there. In this drawing made on the Continent
during 1774–75, Wright observes them close up, almost looming over them.[14]

From Italy, while touring, he wrote about such sites and made numerous
drawings. Evidently curious about the internal workings of Nature, Wright in
November 1774 wished that his natural philosopher friend and neighbor John
Whitehurst had accompanied him on Mount Vesuvius. Whitehurst's "thoughts
wou'd have enter'd in the bowels of the mountain mine skimed over the surface
only...."[15] Whitehurst's long-researched *Inquiry into the Original State and Formation
of the Earth* (1778) proposed the order of strata in Derbyshire. He created cross-
section illustrations with distinctive marks for each rock layer and took as his
model the marks made by printmakers for signaling colors in coats of arms.[16]

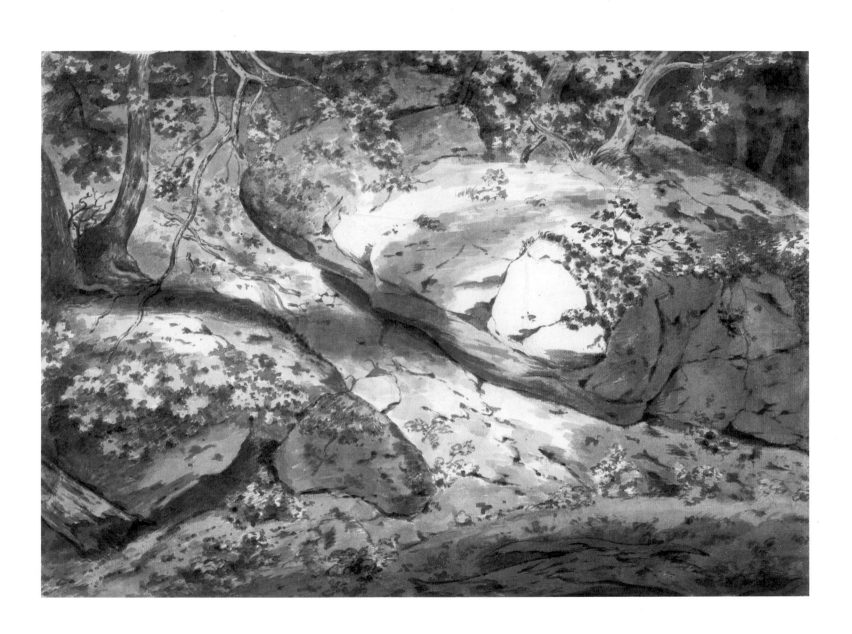

16

JACOB PHILIPP HACKERT
(German 1737–1807, active in Italy)

A Rocky Landscape at Civita Castellana 1776

Brush and brown wash over graphite; framing line in brown ink
13⅝ × 17¹⁵⁄₁₆ in. (34.6 × 45.6 cm) (sheet)
The Metropolitan Museum of Art, Purchase, Mrs. Carl L. Selden
Gift, in memory of Carl L. Selden, 1991
1991.57
Image copyright © The Metropolitan Museum of Art
Image source: Art Resource, NY

In his drawings made in Italy, the Brandenburg-born artist Jacob Philipp Hackert
carefully recorded the individual shapes and outlines of natural wonders such
as the waterfall at Tivoli, Mount Vesuvius, and various cliffs, natural arches,
and caves around Rome and beyond. His precision and choice of subject were
allied with the growing interest in natural history in Germany and Rome during
these years. That attention was spurred in part by Sir William Hamilton's
spectacularly illustrated publication on Mount Vesuvius and nearby volcanic
sites, *Campi Phlegræi, Observations on the Volcanos of the Two Sicilies*, published in
1776. In this large, finished drawing from that year, Hackert drew accumulated
layers of rock, massive boulders, and the forbidding, red tuff canyon walls of
Civita Castellana, an ancient Etruscan town north of Rome established upon a
volcanic plateau. The deposits of tuff had resulted from the hardening spews of
ash, rock, and magma thrown from volcanic eruptions.

Direct observation and the variety of decisive details one actually sees in
nature fed Hackert's appetite for fact-filled landscapes. They also tied him
to Berlin philosopher Johann Georg Sulzer (1720–1779) who espoused the
thorough examination of the land for the aspiring landscapist and advised
the young artist.[17] Such ideas influenced Hackert's youthful years in Berlin
and Paris and later in Rome, where he arrived in 1768 and became a renowned
landscape painter.

à Civita Castellana 1776.

17

ASHER BROWN DURAND
(American 1796–1886)

Where the Streamlet Sings in Rural Joy ca. 1848–49

Oil on canvas
24⅛ × 18¼ in. (61.28 × 46.36 cm)
Frances Lehman Loeb Art Center, Vassar College
Gift of Matthew Vassar
1864.1.26

Closely observed rocks appear in many of Asher B. Durand's studies, drawings, and finished oil paintings made since the mid-1840s, after the professional engraver and rock collector had learned the rudiments of landscape painting.[18] In this oil study, flat, angular, and moss-covered rocks meet the viewer in the foreground, and a stand of surviving hemlock trees represented in botanical clarity tower above. The oil is one of sixty foreground, polished "Studies from Nature" that Durand often painted outdoors, mostly during the 1850s and '60s.[19]

Durand's detailed, smoothed rocks reference eons-old erosion by water and demonstrate his engagement with the aesthetic theories of British artist John Ruskin, whose dictum "truth to nature" in the first volume of *Modern Painters* (1843) was embedded in a passion for geology and painstaking geological representation. Durand's son John bought the 1844 edition for his father in the summer of that year.[20] Years later, in 1857, Durand and his daughter Caroline read *The Old Red Sandstone*, a popular text written by amateur Scottish geologist and paleontologist Hugh Miller.[21] Finally, in a letter written in 1859 from Marbletown, New York, Durand mentions that he will be looking for fossils, but had forgotten to bring along his son Fred's "geological hammer."[22]

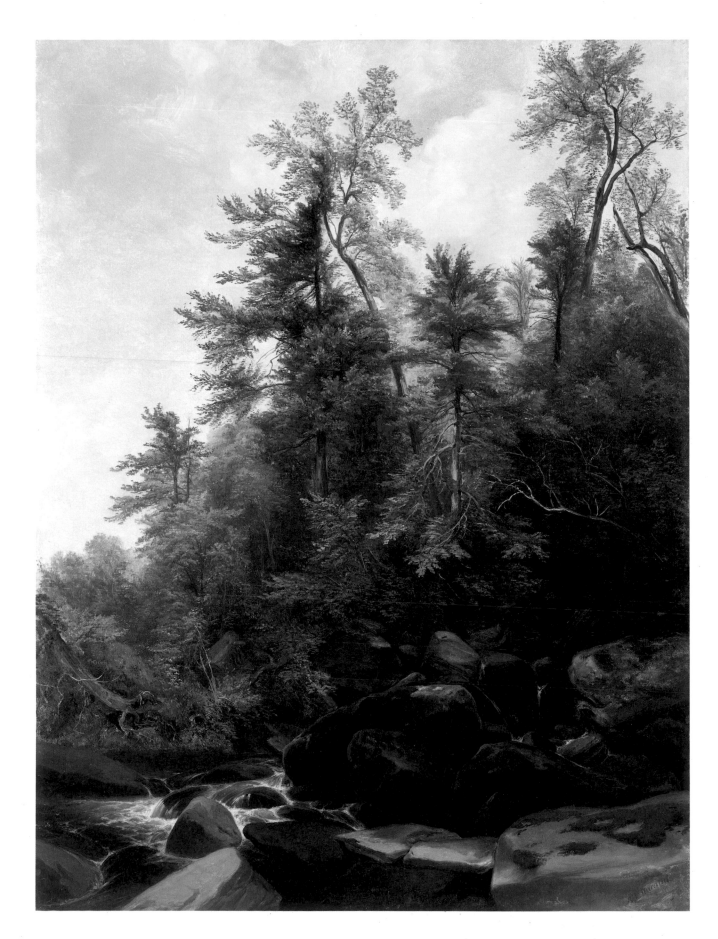

18

SANFORD ROBINSON GIFFORD
(American 1823–1880)

Kaaterskill Clove, September 22, 1848, from the Marbletown, Catskills, and Lake George Sketchbook 1847–48

Graphite on beige wove paper
5¾ × 9¼ in. (14.61 × 23.5 cm) (page)
Frances Lehman Loeb Art Center, Vassar College
Gift of Miss Edith Wilkinson, class of 1889
1938.14.1.80

19

SANFORD ROBINSON GIFFORD
(American 1823–1880)

Evan's Hill, August 12, 1859, and other studies, from the Nova Scotia and New Hampshire Sketchbook 1859

Graphite on beige wove paper
6 × 9⁷⁄₁₆ in. (15.24 × 23.97 cm) (page)
Frances Lehman Loeb Art Center, Vassar College
Gift of Miss Edith Wilkinson, class of 1889
1938.14.3.2

Rocks, cliffs, and mountains—skewed and shaped by the forces of uplift and glaciers—are frequently front and center in many of the works rendered by this Hudson, New York, artist. An admirer of painter and geology enthusiast Thomas Cole, who lived across the Hudson River in the village of Catskill, Gifford appears to have traveled into the nearby Catskill Mountains by 1845.[23] Jagged hills, rock ledges, and glacial boulders energize the pages of an early sketchbook, from 1847–48, used during his hikes in the Catskills and around Lake George. Within it is this vigorous field study drawn on September 22, 1848, looking up toward the sedimentary rock ledges and spewing falls at the deep gorge of Kaaterskill Clove in Haines Falls, New York. The site in the Catskills became a favorite one for the artist and for Cole. In later sketchbooks and in letters, Gifford's interest in geological features is evident through drawings and the use of geological terms. The later sketchbook drawing, shown here, from 1859, features a man holding what may be a portfolio and resting his elbow on a protruding part of an immense rock. Nature's puzzles, these errant boulders were deposited at a distance from their original locations by advancing glaciers. At the time, however, their origins were much debated by geologists advancing varying theories about glaciers such as the Ice Age.

Kauterskill Clove Sept 22nd 1848

18

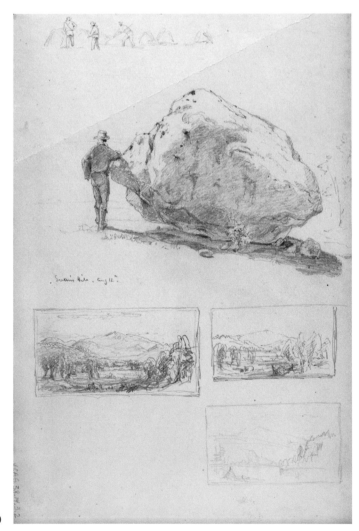

19

JERVIS McENTEE
(American 1828–1891)

Rocks at the Corner 1859

Oil on canvas
14¼ × 10¼ in. (36.2 × 26.04 cm)
Frances Lehman Loeb Art Center, Vassar College
Gift of Ellen G. Milberg, class of 1960, on the occasion of her 50th reunion
2010.3.3

Hudson River School painter Jervis McEntee throughout his professional life rendered dramatically formed outcrops, boulders, and cliffs in his paintings, oil studies, and drawings. An admirer of Asher B. Durand and a student of Frederic Church, the artist hiked and painted and drew in the open air in the Catskills, Maine, the Adirondacks, and near his home in Rondout, New York inspired by these artists, who were both keenly interested in geology.[24] His close friends and hiking partners Sanford Robinson Gifford (cats. 18, 19, 28, 29) and Worthington Whittredge also engaged with an exploratory outlook steeped in the new science.

This naturalistic oil study from 1859 of a rugged, overhanging outcrop bears the mark of McEntee's great interest in painting *en plein air* in the fall and in delineating the rigid surfaces of the earth, especially its stratified and jumbled rocks. The study recalls oil sketches made by Durand with that artist's attention to jutting, tumbled rocks and boulders painted in the open air. This mid-century emphasis on showing great detail of geological features coincided with a focus on the spiritual, owing, in part, to the pervading influence of John Ruskin's truth-to-nature theories on art as laid out in his five-volume book *Modern Painters* published over several years (1843–60). Durand, who turned down McEntee's request for instruction, interpreted Ruskin's principles in an influential series of letters on landscape painting written for the American magazine *The Crayon* and published in 1855.[25]

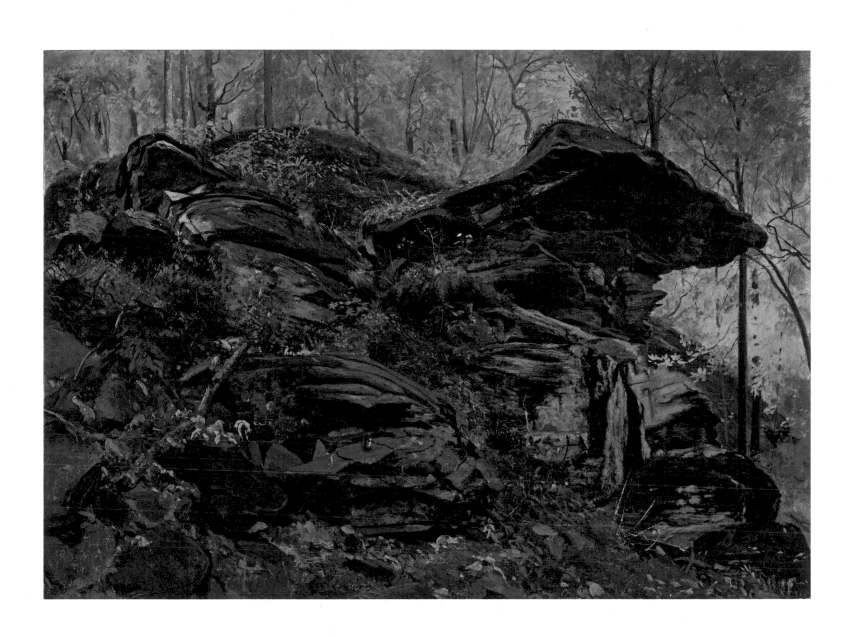

21

JOHN FREDERICK KENSETT
(American 1816–1872)

Berkeley Rock, Newport 1856

Oil on canvas
12 × 19¾ in. (30.48 × 50.17 cm)
Frances Lehman Loeb Art Center, Vassar College
Gift of Matthew Vassar
1864.1.49

By the early 1850s the Hudson River School painter John Frederick Kensett had demonstrated a keen interest in geology through his increasing emphasis on true-to-life rocks with all of their subtle colors and textures, and emphatic, crusty forms. A similar approach by his good friend Asher B. Durand (cats. 17, 36) may have, in part, furthered his attention toward naturalistic rocks as major features in his own paintings, sketches, and drawings.

By the mid-1850s, however, Kensett had shifted his observations away from rocky woodlands to peaceful, luminist, panoramic coastal scenes dominated by lifelike rocks and cliffs and solitary onlookers. Connecting the two styles, Kensett's oil sketch *Berkeley Rock, Newport* of 1856 purportedly shows Anglican bishop George Berkeley (1685–1753) alone atop scarred and jagged cliffs along the coast of Newport, Rhode Island. A light-filled resort for Kensett's patron class, Newport was a favorite summer destination for his plein-air sketching excursions. Berkeley, who wished to establish a college or seminary in Bermuda, was an early Irish empiricist philosopher who lived in Newport during 1729–31 and championed the founding of a literary and philosophical society there.[26] Kensett painted this oil sketch in 1856, the same year Dr. Elias Lyman Magoon purchased it from him and discussed the poems and ideas of the Irish bishop admiringly in his book *Westward Empire*.[27]

FREDERIC CHURCH
(American 1826–1900)

Petra, Study of Rocks 1868

Brush and oil on cardboard with brown backing
4½ × 9 in. (11.5 × 22.8 cm)
Cooper Hewitt, Smithsonian Design Museum
Gift of Louis P. Church, 1917
1917-4-813-b

American painter Frederic Church, who had a searching, scientific approach
to his landscape art, showed his deep interest in rocks in this small oil-sketch
"portrait" of rocks at Petra. An ancient desert city located in present-day Jordan,
Petra features magnificent buildings and other structures carved out of towering,
massive walls of red sandstone, a sedimentary rock sometimes containing fossils.
Having recently won a gold medal at the Paris exposition, Church in February
1868 made a sketching trip to Petra, "that strange mysterious city which few
have seen and that few only glanced at," he noted.[28] On the pass to reach Petra,
Church observed "the most terrible crags and yawning chasms I ever saw jagged
black rocks piled up in awful grandeur—We were lost in amazement."[29]

 After climbing Mount Hor, he and his caravan found Petra, and went
immediately through a tall crevice to the El Khasne temple. They stayed in
Petra for two and a half days and Church made several contour pencil drawings
and oil studies. His "Petra Diary" is part of the collection at Olana, Church's
hilltop estate in Hudson, New York (OL.1985.1).[30] In this rapidly painted sketch,
Church renders the brilliant pink and red colors and patterning present in Petra
sandstone as if he were peering through a magnifying glass. Clearly intrigued, he
owned rocks from Petra among his rock and fossil collection at Olana, including
red sandstone and a chert from El Khasne (see cats. 23b, 23d).

23 a–d

NATURAL SPECIMENS FROM THE COLLECTION OF FREDERIC CHURCH
(American 1826–1900)

Collection Olana State Historic Site, Hudson, NY, New York State Office of Parks, Recreation and Historic Preservation

Like his mentor Thomas Cole, Hudson River School painter Frederic Church formed a rock, mineral, and fossil collection. Comprising over eighty natural specimens, it includes those shown here as well as pumice stone, quartz, lava, oyster shell, gastropods, and coral, among others. Though the specimens in the collection are accessioned and described by shape and color, most await geological and paleontological identification. The artist collected many, it appears, for their distinctive decorations and source locations. —PP

a

Sedimentary rock probably from the Green River Formation, with fish-tail and -spine fossil
5½ × 5 in. (13.97 × 12.7 cm)
OL.1989.216
(Vassar only)

This fossiliferous sedimentary rock likely from the Green River Formation represents the presence of freshwater lakes and a sub-tropical, moist climate in western Colorado, eastern Utah, and southwestern Wyoming in the United States during the Paleogene Period (66 to 23 million years ago) of the Cenozoic Era.

b

Dark red Umm Ishrin sandstone from the Ram Formation, Petra, Jordan
1⁵⁄₁₆ × 1⅛ in. (3.33 × 2.86 cm)
OL.1989.253.a

The Umm Ishrin sandstone forms Petra's red-faced monuments. The oldest in a series of sandstone formations, the Umm Ishrin sandstone consists of coarse- to medium-grained quartz clasts, shot through with an iron- and manganese-rich matrix, and varies in color from red to yellow to chocolate. It is the remnant of a large braided stream system that existed during the Cambrian Period (541 to 485 million years ago).

c

Agate with manganese dendrites ("mossy agate")
1⅜ × ½ in. (3.49 × 1.27 cm)
OL.1989.288

This translucent sample of chalcedony, a microcrystalline form of quartz, has black, dendritic inclusions of manganese oxide with an organic form. Such "mossy agate" is most famously found in the Yellowstone River Basin of southeastern Montana.

d

Chert-cryptocrystalline quartz from El Khazneh at Petra, Jordan
1⅞ × 1½ in. (4.76 × 3.81 cm)
OL.1989.244

Chert is a microcrystalline form of quartz. Sometimes known as "flint," chert typically breaks with a conchoidal fracture, often producing very sharp edges. Early people took advantage of how chert breaks and used it to fashion cutting tools.

JSS

Dimensions are height by width. Many thanks go to Thomas R. Paradise and Marian Lupulescu for their assistance in identifying these specimens.

a

c

b

d

24 a–f

NATURAL SPECIMENS FROM THE
A. SCOTT WARTHIN GEOLOGICAL MUSEUM
VASSAR COLLEGE

a

Pink, welded tuff, Death Valley, California
1⅜ × 4⁵⁄₁₆ × 3⅜ in. (3.5 × 11 × 8.5 cm)

Explosive volcanic eruptions produce welded tuff. The hot, composite mixture of ash, glass, minerals, and rock fragments ejected from the volcano flattens and fuses together when it reaches the ground. Shards of flattened glass can be seen in this specimen.

b

Fine-grained basalt column, Palisades, New Jersey
4⁵⁄₁₆ × 4⁵⁄₁₆ × 14¹⁵⁄₁₆ in. (11 × 11 × 38 cm)

Basalt is a dark-colored, fine-grained volcanic rock created by the rapid cooling of lava at or near the earth's surface. The geometric columnar shape of the basalt formed naturally when the rock contracted upon cooling.

c

Granitic biotite gneiss, location unknown
4⁵⁄₁₆ × 6⁵⁄₁₆ × 2¾ in. (11 × 16 × 7 cm)

A banded metamorphic rock consisting of alternating layers of light and dark colored minerals, this gneiss includes the minerals biotite, quartz, and feldspar. The banding has been disrupted by folding (a pliable deformation of rock) and the intrusion of milky quartz veins.

d

Slickensides in serpentinite, Belvidere Mountain, Lowell, Vermont
4⁵⁄₁₆ × 9¹³⁄₁₆ × 9⁷⁄₁₆ in. (11 × 25 × 24 cm)

Slickensides are smooth, lineated, and grooved surfaces that occur when the rocks along a fault (a brittle deformation of rock) rub against one another producing a natural polish. The green color of the rock comes from minerals derived from the earth's mantle (a region beneath the crust).

e

Fossil fern, Neuropteris hirsuta, Carbondale, Pennsylvania
1³⁄₁₆ × 12⁹⁄₁₆ × 9¹⁄₁₆ in. (3 × 32 × 23 cm)

The fossilized leaves of this cycad-like seed-fern from the Carboniferous Period (360–299 million years ago) indicate a humid, tropical climate.

f

Finely laminated limestone, Hudson River Valley, New York
4¹¹⁄₁₆ × 7⅞ × 9¹³⁄₁₆ in. (12 × 20 × 25 cm)

A sedimentary rock composed mainly of the mineral calcite, limestone commonly forms in clear, warm, and shallow marine waters. It is the protolith (parent rock) of marble.

JSS

Dimensions are height by width by depth.

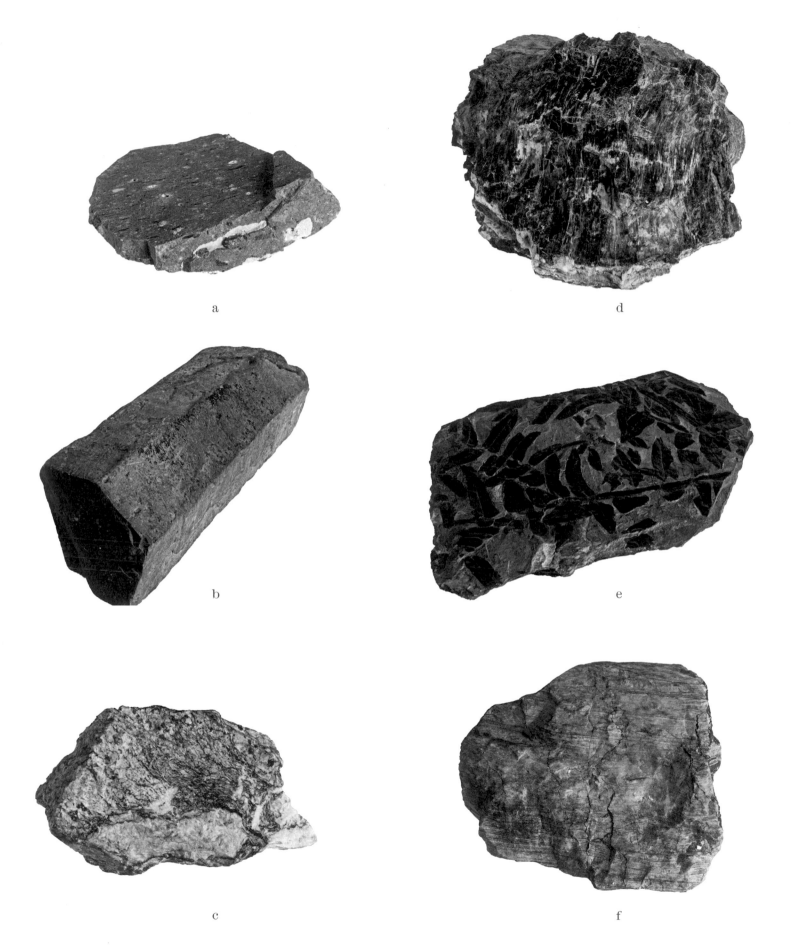

a

d

b

e

c

f

25

SAMUEL PALMER

(British 1805–1881, active in Italy 1837–39)

Llyn Gwynant and Part of Llyn-y-Ddinas between Capel Curig and Beddgelert, North Wales 1835 or 1836

Gouache, watercolor, graphite, and black chalk on medium, smooth, brown wove paper
15 × 18⅛ in. (38.1 × 46 cm) (sheet)
Yale Center for British Art, Paul Mellon Collection
B1975.4.1948

As late as 1875, Samuel Palmer longed for the fusing of geology and art in drawing and in artistic knowledge. Writing to patron L. R. Valpy at that time, Palmer explained, "I must have ill expressed my meaning if it seemed that I would exclude geological drawing from art drawing. It seems to me that art drawing includes it, as figure drawing includes anatomy." He added, "Nature knowledge and art knowledge ought to be in harmony, but they are two distinct things."[1]

It seems probable that Palmer formed his views on this mingling of geology and art in the 1830s. The new science garnered wide exposure in Britain then through controversial ideas on the earth and how it changes over time by geologists Charles Lyell and William Buckland and through the popular press. The artist's panoramic view of the Llyn Gwynant valley in Snowdonia, North Wales, is one of a number of watercolors Palmer made in 1835–36 where he evoked a distinct interest in geology.[2] Here he presents a seemingly primordial volcanic landscape of meandering streams and zigzagging peaks emerging briefly from their cloak of clouds and fog. The Turneresque watercolor recalls Palmer's description of extinct volcano Mount Snowdon in 1835, "...we had just a glimpse or two one day thro' the chasms of stormy cloud which was sublime...."[3]

26

JOHN ROBERT COZENS
(British 1752–1797)

Near Chiavenna in the Grisons ca. 1779

Watercolor, black ink, graphite and gray wash on moderately thick,
slightly textured, cream laid paper
16¾ × 24½ in. (42.4 × 62.2 cm) (sheet)
Yale Center for British Art, Paul Mellon Collection
B1977.14.4634

From his early exhibiting years, John Robert Cozens showed interest in a
seminal geological phenomenon of his time, the Alps. His father, Alexander
Cozens (1717–1786), teacher, pioneer landscape theorist, and draughtsman, took
extraordinary interest in codifying for artists and students the compositions
found in nature through its rocks, landforms, and water, and its varied
"circumstances" of light, seasons, and climate.[4] Indeed, John Robert was
familiar with his father's system of mountainous landscape compositions.

 In the summer of 1776 he journeyed through the Alps and into Italy,
accompanied by his patron Richard Payne Knight (1751–1824), a young,
wealthy Englishman, drawings collector, and theorist on the picturesque.
Cozens was to document the journey to Italy, passing through the Alps first.[5]
This large, powerful work, probably made later in Italy, presents an apparent
campfire set before jutting, misshapen boulders and rock walls in the Alps,
near Chiavenna.[6] Cozens forces us to look at the strata in their undulating
roughness, resembling clay squeezed in one's fist. As a landscapist in Rome, he
would have likely been exposed to the great interest in geology among artist
friends like Thomas Jones, spurred in part by the publication of Sir William
Hamilton's *Campi Phlegræi* in 1776.

27

JOSEPH MALLORD WILLIAM TURNER
(British 1775–1851)

Tell's Chapel, Lake Lucerne 1841

Watercolor, gouache, and scraping out on medium, slightly textured,
cream wove paper with watermark J. Whatman/Turkey Mill/1840
8 7/8 × 11 1/4 in. (22.5 × 28.6 cm)
Yale Center for British Art, Paul Mellon Collection
B1975.4.1419

Turner presents an ethereal watercolor of a glacial lake in the Swiss Alps, with
chiseled cliffs eroded by massive glaciers. Originating in a sketchbook from an
alpine tour of around 1841, the work exudes the Sublime and accentuates the
craggy mountains and Axenberg mountain cliffs on the eastern shore of Lake
Lucerne, near the village of Sisikon.[7] The cliffs were well known at the time
for folds. "From the top to the bottom of this high calcareous mountain the
strata are in the form of a compressed S, or with very sharp bends, many times
redoubled, and often in contrary directions," noted a writer in 1809.[8] A quickly
rendered image of William Tell's Chapel rests at the bottom of the Axenberg
cliffs and commemorates where Tell escaped from a boat taking him to prison.[9]

 Turner's emphasis on the peaks, glacial lake, and sculpted cliffs signals his
serious interest in geology, which extended to friendships with geologists such
as John MacCulloch (1773–1835) and with other members of the Geological
Society of London, including Charles Stokes (1785–1853) and Francis Chantrey
(1781–1841). The artist owned the two earliest volumes of the organization's
journal *Transactions* (1811–1814).[10] Turner's ability to suggest the truths of
nature through a sense of the Sublime and a refined sense of geological
structure attracted art critic, artist, and geologist John Ruskin, who initiated
his book *Modern Painters* as a defense of Turner against artistic criticism.

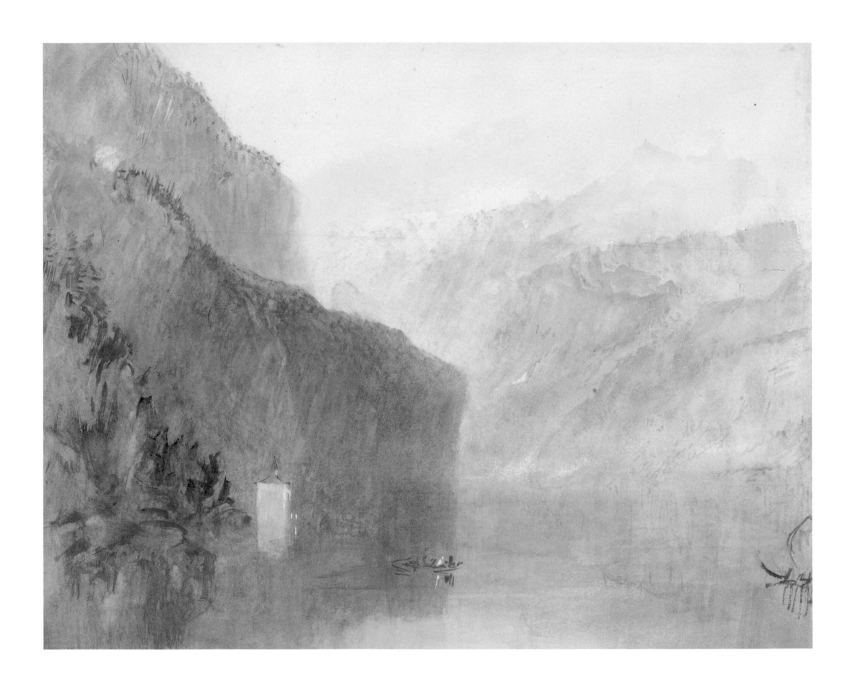

28

SANFORD ROBINSON GIFFORD
(American 1823–1880)

Sunrise on the Bernese Alps 1858

Oil and graphite on canvas
9 × 15½ in. (22.86 × 39.37 cm)
Frances Lehman Loeb Art Center, Vassar College
Gift of Matthew Vassar
1864.1.36

29

SANFORD ROBINSON GIFFORD
(American 1823–1880)

Lago Maggiore 1859

Oil and graphite on canvas
5¾ × 10¼ in. (14.61 × 26.04 cm)
Frances Lehman Loeb Art Center, Vassar College
Gift of Matthew Vassar
1864.1.33

As with Thomas Cole and other Hudson River School painters, mountainous and rocky scenery and interesting geological formations consistently attracted Sanford Robinson Gifford. His Grand Tour of 1855–57 was no exception, with his attention drawn to Atlantic icebergs, the High Tor cliff in Derbyshire, Fingal's Cave in Scotland, and the Alps, with numerous sites described with geological language and drawings in his journal. He even noted that he would have benefited from having a geologist, a Mr. Pinchion, along on his journey in Italy.[11]

On August 16, 1856, Gifford hiked the Simplon Pass, a road in the Swiss Alps, noting the sun's "rich glow over the snows and peaks of the Bernese chain, whose magnificent panorama was spread out behind me...."[12] *Sunrise on the Bernese Alps*, painted for Dr. Elias Lyman Magoon long after this trip, features finger-like pinnacles, or aiguilles, framing an ocean of pencil-outlined peaks ranging from layers of grainy blue to delicate pink.[13]

The very next day, August 17, Gifford took a diligence from Domodossola south to Baveno, on the western coast of Lake Maggiore. On the 18th he rowed to the islands of Isola Madre and Isola Bella and the next day made an oil sketch of Isola dei Pescatori.[14] In 1859, he rendered this small, rapidly painted, sun-struck scene of Lake Maggiore for Dr. Magoon.[15]

28

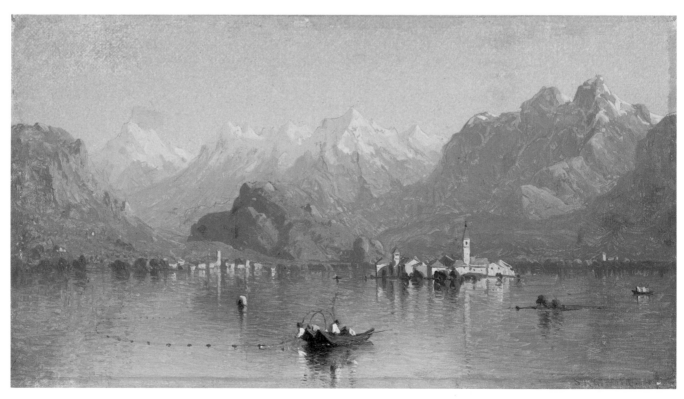

29

30

FREDERIC CHURCH
(American 1826–1900)

Königssee, Bavaria 1868

Brush and oil paint, and graphite on thin cream paperboard
11⁷⁄₁₆ × 11⅞ in. (29 × 30.1 cm) (sheet)
Cooper Hewitt, Smithsonian Design Museum
Gift of Louis P. Church
1917-4-562-b

Like most of his fellow Hudson River School landscape painters, Frederic
Church traveled the Alps on his journeys through Europe. In the nineteenth
century these monumental ranges attracted waves of artists and scientists
interested in documenting the magnificent, otherworldly peaks and
glaciers and tracking their history. Church, who had a deep interest in
geology, journeyed through the Alps in June–September 1868 with his
wife, after his trip to Petra, Jordan, in February (see cats. 22, 23b, 23d).[16]

The steep mountains and deep, jade-colored lake of the popular tourist
site Königssee and nearby lake Obersee attracted Church immensely, enticing
him to visit almost every day when visiting nearby Berchtesgaden for six
weeks. The Königssee entranced him, and he would stay there "12 to 15
hours daily—sketching furiously."[17] The glacial lake rests between the rising
mountain walls of the Bavarian Alps, at Berchtesgaden, situated near the
border with Austria. With glass-like effects, Church painted the deep water
in this study confidently, mastering mesmerizing reflections of the looming
precipices, especially the rocky Kreuzelwand on the right, and the paths
of waves. The view is looking southwest, from a location not far from the
Painter's Corner, or Malerwinkel, and is related to two other oil sketches of
Königssee by Church housed at the artist's Hudson River estate, Olana.[18]

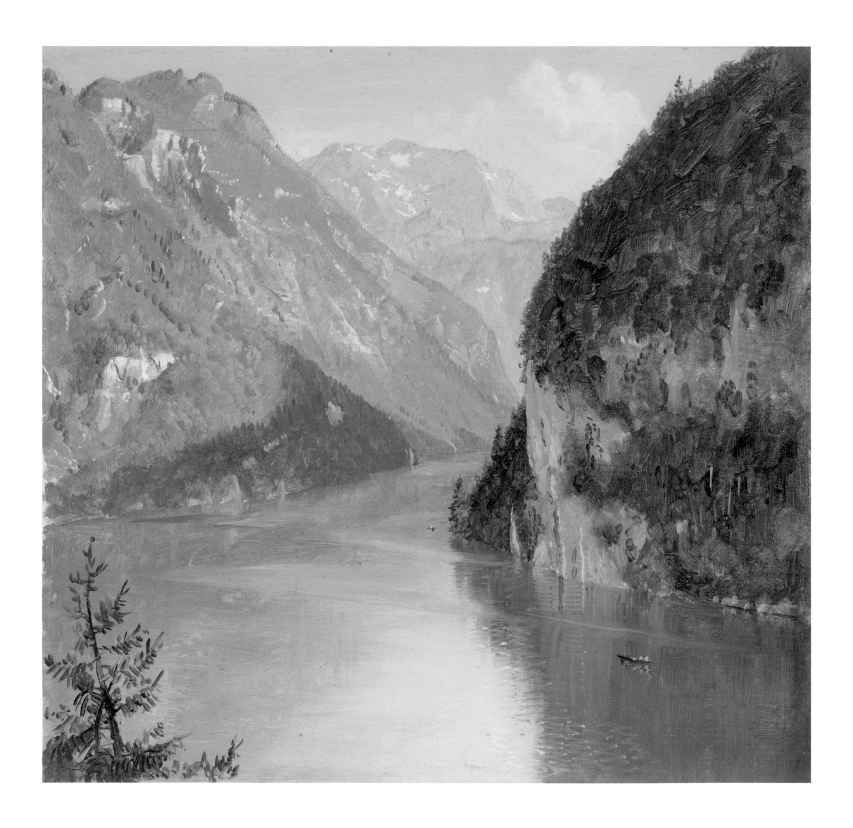

31

CARL MORGENSTERN
(German 1811–1893)

Jungfrau, Mönch, and Eiger

Oil on paper, laid down on cardboard
10⅜ × 14 in. (26.4 × 35.6 cm)
The Metropolitan Museum of Art, Thaw Collection
Jointly Owned by The Metropolitan Museum of Art and The Morgan Library & Museum
Gift of Eugene V. Thaw, 2009
2009.400.89
Image copyright © The Metropolitan Museum of Art
Image source: Art Resource, NY

As an artist, Frankfurt-born landscape painter Carl Morgenstern encountered
rocky terrain in his excursions to the German countryside and further
afield to the Alps and to Italy. In the early 1830s he studied in Munich under
Carl Rottmann (1797–1850), well known for his geologically rich subjects
and quick landscape oil sketches. Afterwards, the young artist studied in
Italy, where his experience of the brilliantly lighted, rugged land informed
his finished paintings with their polished effects of air and sunshine.

Morgenstern made four sketching tours of the Swiss mountains, in 1849,
1851, 1856, and 1864.[19] He visited the general area of the Jungfrau in 1851
when he remarked that he had gone to the Wengernalp, a valley northwest of
the Jungfrau, Mönch, and Eiger peaks.[20] In this loosely painted oil sketch of
the trio, Morgenstern shows their other side, where the Aletsch glacier lies like
a thick white frozen river. The massive flow of ice, the most prominent glacier
in the Alps, plunges between the peaks and laps their slopes. Morgenstern
quickly and broadly rendered this rough sketch, likely *en plein air*, perhaps
standing on a nearby slope. His ecstatic sunset blaze of colors and crags and
shadowed glacier confront the viewer. For decades the three closely placed
mountains and glacier had been the subjects of climbs and scientific theories,
by Louis Agassiz (1807–1873) and others, on a possible Ice Age and on the
question of glaciers moving boulders and debris along in slow motion.[21]

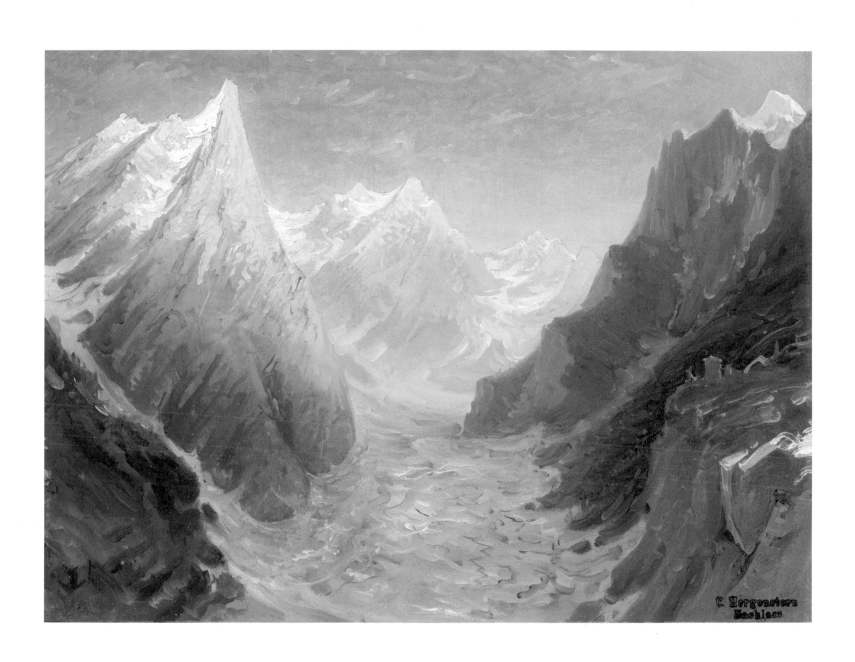

HENRY MOORE
(British 1831–1895)

Mer de Glace 1856

Watercolor and gouache over graphite on medium, slightly textured, cream wove paper
10½ × 14⅝ in. (26.7 × 37.1 cm) (sheet)
Yale Center for British Art, Paul Mellon Collection
B1975.4.1344

In this work York-born painter Henry Moore honed in on the pinnacle-like ice forming a part of the Mer de Glace, the huge, winding river of ice at Mont Blanc in the French Alps. Drawn in pencil and then brushed with watercolor washes with astoundingly sculptural effect, the work exudes the artist's strong admiration for the English Pre-Raphaelites. That painting movement, formed in 1848 and vigorous for a few years afterwards, drew upon John Ruskin's truth-to-nature mandate of close geological detail in rendering the earth.

Dated August 18, 1856, Moore's watercolor of the glacier appears to have been completed *en plein air*. Although he would become much better known for his seascape canvases later on, for much of the 1850s Moore painted landscapes, many showing direct study of nature. He trained in York and then at the Royal Academy Schools and Langham Schools.[22] Moore first visited the French Alps in 1855, when he stayed at Servoz, and this was followed by another sojourn to Servoz the following year. Those trips resulted in paintings demonstrating his geological and botanical interests and enthusiasm for working in the open air.[23]

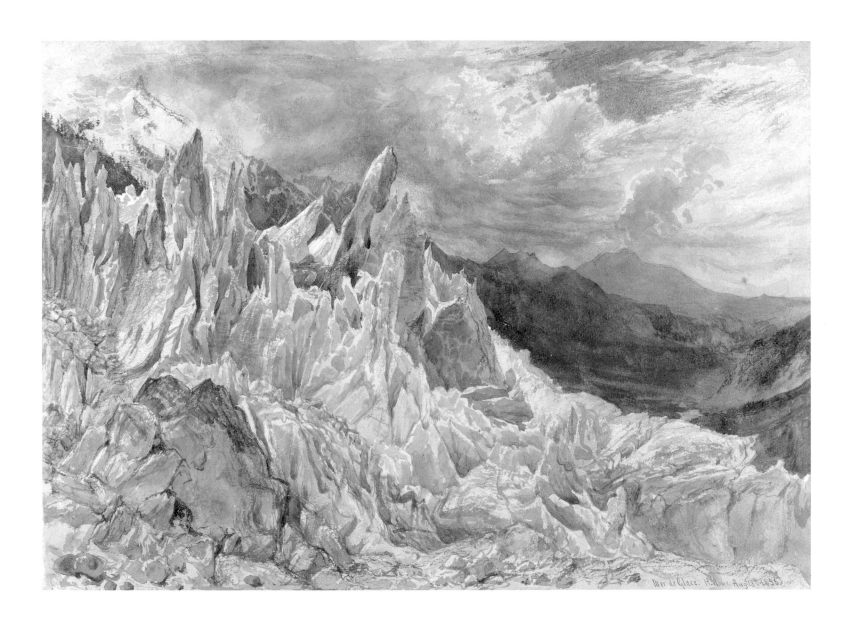

Mer de Glace. H. Moore Aug. 1856

33

JOHN SINGER SARGENT
(American 1856–1925)

Eismeer, Grindelwald, from *Splendid Mountain Watercolours* Sketchbook 1870

Watercolor and graphite on off-white wove paper
16 × 10⅞ in. (40.6 × 27.6 cm) (page)
The Metropolitan Museum of Art, Gift of Mrs. Francis Ormond, 1950
50.130.146qq recto
Image copyright © The Metropolitan Museum of Art
Image source: Art Resource, NY

Even a youthful John Singer Sargent, before he became a stylish portrait and watercolor painter, shared the popular enthusiasm to document the inimitable Swiss Alps. He journeyed there with his family in the summers of 1869 and 1870, making side excursions with his father.[24] The youth's watercolor sketch here is loose and painterly and shows an unusual perspective, unlike many of the other landscapes in his 1870 *Splendid Mountain Watercolours* sketchbook. Rather than record a panoramic view, it vigorously documents a detail, actually a hole, or moulin, along their hike near the village of Grindelwald, where a jet of blue glacial water and ice burrowed deep into a crevasse edged with boulders.

 With this and other alpine views, the young Sargent participated wholeheartedly in a field-study, open-air tradition of drawing among artists, especially those journeying in the Alps. Schooled mostly by his surgeon father, the Florence-born Sargent may have received some art training in the winter of 1868–69 from Carl (Charles Feodor) Welsch (1828–1904). From Germany, Welsch was living in Rome and had trained at the Düsseldorf Art Academy in 1846 under Johann Wilhelm Schirmer (1807–1863), an assiduous painter of alpine views and other rocky, mountainous sites.[25]

34

EUGÈNE-EMMANUEL VIOLLET-LE-DUC
(French 1814–1879)

Mont Blanc Seen from the Massif, Les Aiguilles Rouges 1874

Watercolor heightened with gouache over traces of graphite on two sheets
of blue-gray wove paper (glued together in a vertical seam at left)
11⁷⁄₁₆ × 26⅛ in. (29 × 66.4 cm) (sheet)
The Metropolitan Museum of Art
Purchase, Isaacson-Draper Foundation Gift, 2005
2005.78
Image copyright © The Metropolitan Museum of Art
Image source: Art Resource, NY
(Vassar only)

A well-known architect and restorer of several Gothic churches and
cathedrals in France, Eugène-Emmanuel Viollet-le-Duc also had a
profound interest in the geologic structure of the Alps, especially Mont
Blanc. In his later years he published a lengthy, illustrated treatise on
Mont Blanc, the highest peak in the Alps, and greatly admired the
observations on the mountain made by Henri de Saussure who climbed
it in 1787.[26] Viollet-le-Duc's study *Le Massif du Mont Blanc* appeared in
1876, after the author had spent eight summers aimed at working up
a map locating the mountain's rocks, glaciers, and moraines.[27]

 The depth of his descriptions in the published study matched the
thoroughness with which he drew the precipice in this drawing with its
field of pebbly rocks. The highly detailed, close view of Mont Blanc was
completed two years before, on 7 August 1874, from the nearby Aiguilles
Rouges.[28] It may have been aided with a long-distance instrument
called a *téléiconographe*, which combined the features of a surveyor's
scope and a *camera lucida* and which the artist championed.[29]

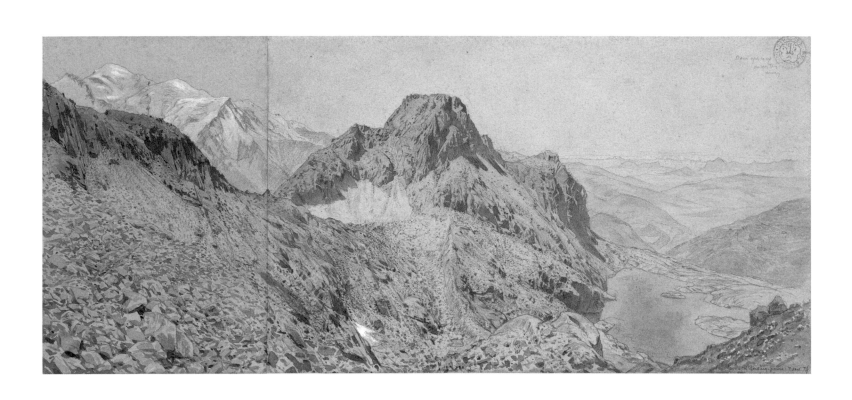

35

ISAAC WELD
(Irish 1774–1856)

Vesuvius in Eruption

Watercolor, gouache, graphite, and wash on moderately thick,
moderately textured, cream wove paper
9¹⁵⁄₁₆ × 14¾ in. (25.2 × 37.5 cm.)
Yale Center for British Art, Paul Mellon Collection
B1981.25.2910

A travel writer, topographer, and geologist, the Dublin artist Isaac Weld explored
lands as diverse as North America and Ireland, describing people and places, and
providing descriptive drawings of land features that were translated into prints.
Finding after his well-received sojourn in America and Canada that he could
explain little about geology and mineralogy, he began studying the specimens at
the Royal Society of Dublin.[30] The Society collected materials from various sites,
including Mount Vesuvius, for its rock and mineral collections.[31] Weld would
become a member and officer of the Society, and in time he would also join the
Royal Irish Academy and the Geological Society of Dublin.

 The artist traveled on the Continent, spending lengthy periods in various
cities, including Rome, Turin, Naples, Geneva, and Bern, and meeting British
chemist and geologist Humphry Davy (1778–1829) along the way.[32] About 1818
Weld made a topographical watercolor of a distant Mount Vesuvius seen from
the verdant, residential banks of the Bay of Naples (*Vesuvius Across the Bay of Naples,*
Yale Center for British Art, B1981.25.2913). In contrast, he made this nocturne
watercolor of an erupting Mount Vesuvius, with clouds of steam billowing up,
lava flowing down its slopes, and fiery pieces of rock spewing out like fireworks.

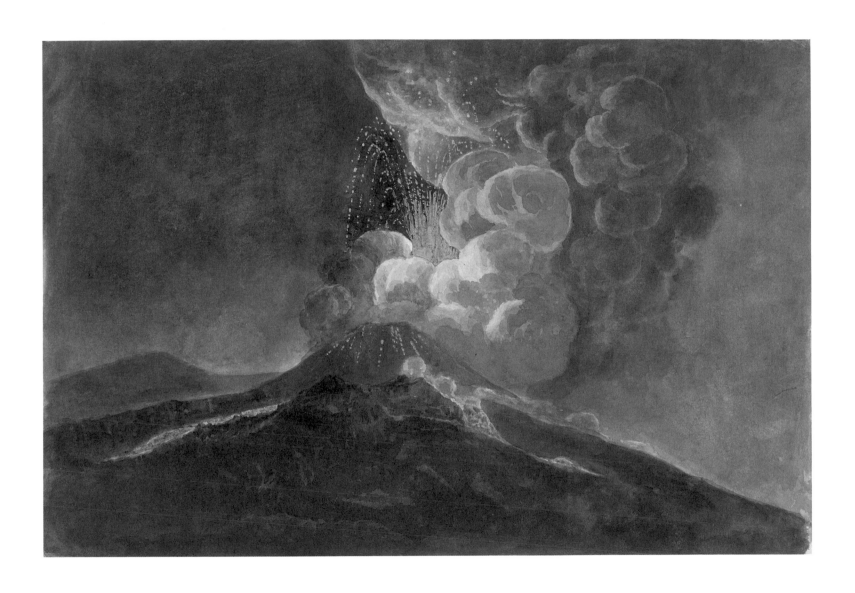

ASHER BROWN DURAND
(American 1796–1886)

Caldera of Mt. Vesuvius, Naples, Italy 1841

Graphite on ivory paper
10³/₁₆ × 14³/₈ in. (25.9 × 36.5 cm)
The New-York Historical Society, Gift of Miss Nora Durand Woodman
1918.114
Photography © New-York Historical Society
(Cornell only)

Accompanied by friends, including artists John W. Casilear (1811–1893) and John
Frederick Kensett, Asher B. Durand traveled to Europe, setting out on a steamer
to London in June 1840.[33] As he referenced the icons of art and architecture he
saw along the way in his journal, he also cited celebrated geological features.
Early in the trip when bound for a stop at Portsmouth, he rose early to see the
jagged chalk formations called The Needles, located off the Isle of Wight, but
the dense fog hung too heavily to view them clearly.[34] Further on he noted the
white chalk cliffs of Dover.[35] Once he was on the river Rhine in Germany much
of the scenery captured his attention. Then upon first seeing the Alps in northern
Switzerland, he wrote ecstatically, "The sight was electric."[36]

In March 1841, Durand wrote from Rome to his wife Mary, noting the coming
trip to Naples and its surroundings, including Mount Vesuvius which was said
to show signs of erupting. He remarked, "I hope that is so for I should like much
to witness it at a distance."[37] As shown here, Durand sketched its crater, a jagged
mouth guarding clouds of billowing steam. In a letter to Jonathan Sturges, he
noted, "We asscended [sic] the old Volcano, and looked down into its fearful
crater snuffing up liberal portions of sulphurous smoke."[38]

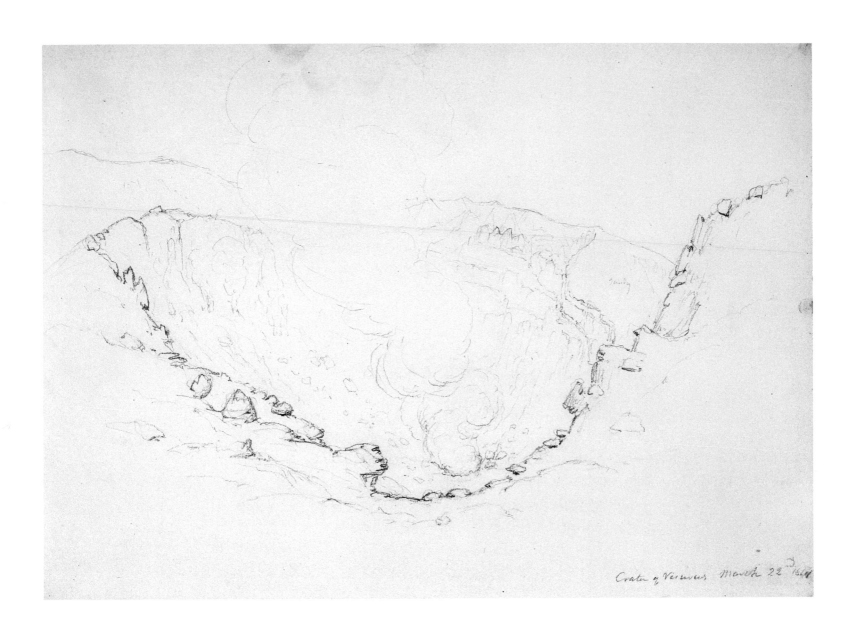

Crater of Vesuvius March 22 1868

37

THOMAS COLE
(American, b. England 1801–1848)

Medieval Buildings, Sicily ca. 1842

Oil on panel
6 × 9 in. (15.24 × 22.86 cm)
Frances Lehman Loeb Art Center, Vassar College
Gift of Constance Wilckes Dohrenwend, class of 1928
1993.15

In May 1842 Thomas Cole, the early leader of the Hudson River School, climbed Mount Aetna on the island of Sicily while on a second tour of Europe. Setting out on mules at night, he and his retinue traveled over lava, hiked on foot over the snow, and finally trekked up the volcanic cone on beds of ashes, cinders, and hardened lava to reach the summit at daybreak. Cole looked out at Sicily with its "'many folded' mountains" and looked down into the crater with its depth of more than 1000 feet with some sides "rent into deep chasms and gulfs, from which issued white sulphurous smoke, that rose and hung in fantastic wreaths about the horrid crags...."[39]

 A mineral, rock, and fossil collector and friend to several professional and gentleman geologists, Cole demonstrated an intense interest in geology throughout his artistic career in the 1820s, '30s and '40s, when the science grew in popularity in the United States.[40] Considered by the 1830s a part of one's cultural education, geology infused literary and artistic circles, and energized much plein-air sketching during this era.[41] This small oil sketch by Cole shows Mount Aetna in the distance. The artist made the work in preparation for his painting of the ancient goddess of springtime, Proserpine, which was left unfinished at his death in 1848.[42]

38

ALBERT BIERSTADT
(American, b. Germany 1830–1902)

Geyser, Yellowstone Park ca. 1881

Oil on paper mounted on paperboard
13⅞ × 19½ in. (35.24 × 49.53 cm) (sheet)
Museum of Fine Arts, Boston
Gift of Martha C. Karolik for the M. and M. Karolik Collection
of American Paintings, 1815–1865
47.1253
Photograph © 2018 Museum of Fine Arts, Boston

Picturing an almost tangible otherworld, American painter Albert Bierstadt rendered Castle Geyser shooting a cloud of boiling water near the hot spring Crested Pool in this oil sketch related to his first visit to Yellowstone in 1881. Established in 1872 by the U.S. Congress, the park is found mostly in Wyoming and holds around 500 geysers, more than half of the world's total. At around 8,000 feet, the plateau sits upon an immense, active supervolcano whose magma, or molten rock, exists directly below the earth's crust and feeds the heat needed for the area's geysers and hot springs.[43]

Bierstadt was drawn to geologically dominating landscapes like Yellowstone.[44] As he described his trip there, "I have always had an inclination towards geological studies, and here I had a whole world of geological phenomena spread before me."[45] He may have made the color study on site, one of several "which I intend as jogs to my memory...," he noted.[46] Bierstadt's thickly painted work has roots in plein-air landscape painting in Düsseldorf, where the artist, born in nearby Solingen, studied in the mid-1850s. Bierstadt made the field study and the dramatic, rugged, geological landscape mainstays of his work.[47]

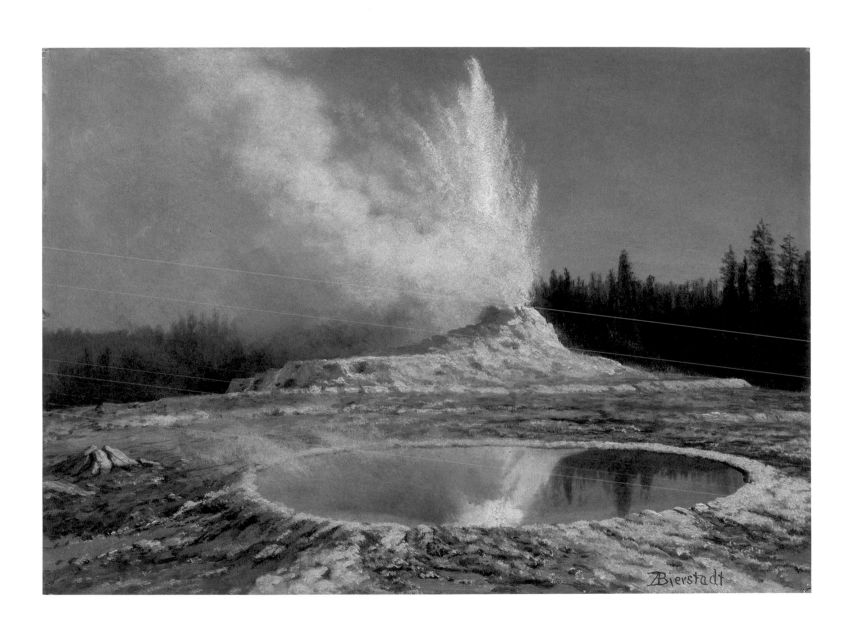

39

THOMAS MORAN
(American, b. England 1837–1926)

Back of the South Dome from the Nevada Trail, Yosemite 1891

Brush and gray, black, and white wash, and graphite on gray paper
9¹³⁄₁₆ × 12¾ in. (24.9 × 32.4 cm)
Cooper Hewitt, Smithsonian Design Museum, Gift of Thomas Moran
1917-17-75

As a volunteer topographer, American artist Thomas Moran joined the U.S. Geological and Geographical Survey of the Territories expedition in 1871 on its journey into the Yellowstone region. Drawings of the mountains, precipices, falls, and hot springs followed. During the summer and early autumn of 1872, Moran and his wife Mary Nimmo Moran visited Yosemite, more than 900 miles to the southwest of Yellowstone, in California. His pencil and brush became extraordinarily busy, and he seemed to relish drawing the mountains there, with sweeping lines, sharp angles, and abrupt curves and stops of the wrist.[48] The dynamic views demonstrably energized him. The North Dome, South Dome, Sentinel, El Capitan, Nevada Falls, Vernal Falls, and Yosemite Falls seized Moran's attention, led by the lines, arcs, and angles that formed the sheer cliffs, glacial valleys, and erosion of an extraordinary landscape. Decades later he referenced Yosemite in this inventive wash and pencil drawing, executed in 1891, of South Dome from the Nevada Trail.

Moran had come to the United States from England when he was around seven years old. After a wood-engraving apprenticeship, the Philadelphia artist shifted to illustration and painting, and became engrossed in the paintings and drawings of the Hudson River School and J. M. W. Turner. During a trip in 1860 to the Upper Peninsula of Michigan, he made carefully observed documentary line drawings of Pictured Rocks at Lake Superior, thus forecasting a career of making field sketches of geological sites.[49]

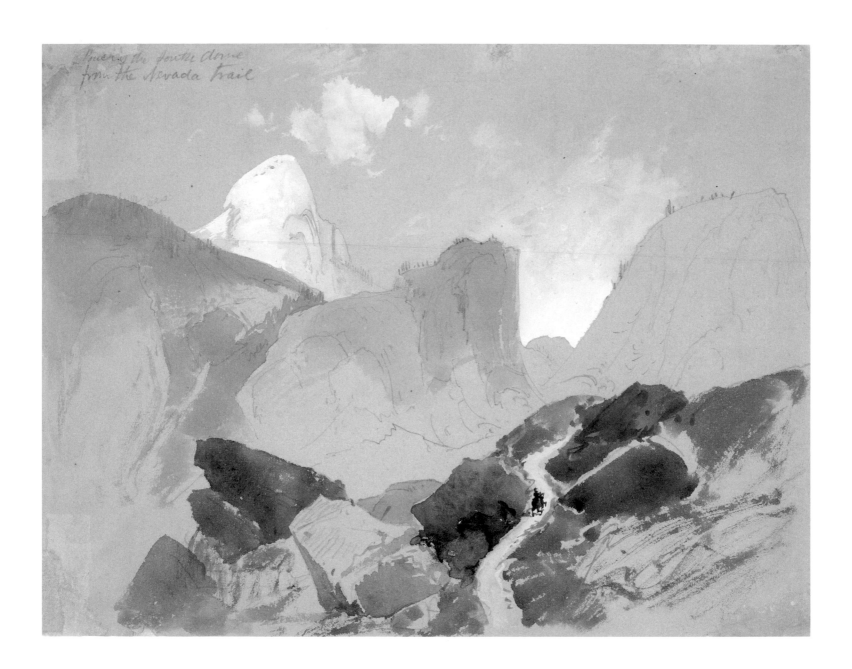

40

FREDERIC CHURCH
(American 1826–1900)

Mount Chimborazo at Sunset ca. July 1857

Oil on academy board mounted on canvas
12 × 21⁷⁄₁₆ in. (30.5 × 54.5 cm)
Collection Olana State Historic Site, Hudson, NY, New York State Office of Parks,
Recreation and Historic Preservation
OL.1980.1884

Frederic Church made pencil sketches of the volcano Mount Chimborazo on his journey to Ecuador in 1857, and this oil study of it appears to have been made during this trip.[50] When Church attempted the journey to the summit of the volcano Mount Sangay, further south, he noted the land was cracked like "pentagonal prisms" and there were areas of quartz, some with gold flakes, and riverbed sediment of black sand. He was taken aback at Sangay's distant "serrated black, rugged pile of rocky mountains" which shaped the volcano's crater.[51]

The Hudson River School landscape painter, one of the most scientifically engaged American artists of the nineteenth century, was an avid reader of naturalist and geologist Alexander von Humboldt (1769–1859). Church owned copies of Humboldt's travel journals and his book *Cosmos*, and was inspired by the geologist to travel in his footsteps.[52] Humboldt had failed to reach the Chimborazo summit, like Church, on his much earlier expedition, but he pictured the volcano in scientific illustrations in his publications including *Personal Narrative of Travels* (1819–29). Later on in *Cosmos* Humboldt called on artists to carefully draw or paint from nature, using color sketches as a storehouse for later use, a directive which Church seems to have taken to heart on his expeditions.[53]

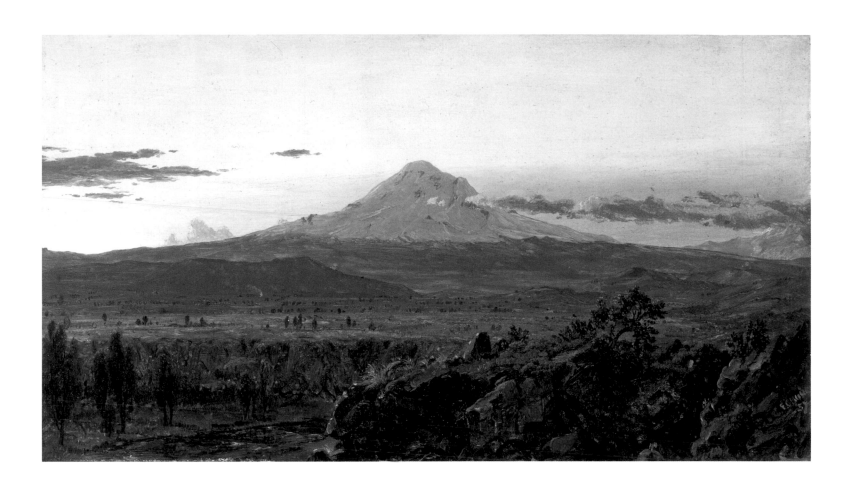

41

ALFRED DISTON
(British, active 1818–1829)

The Peake of Tenerife 1829

Watercolor, pen, gray ink, brown ink, black ink, gray wash, and graphite
on moderately thick, slightly textured, cream wove paper
13¾ × 16⅞ in. (34.9 × 42.9 cm)
Yale Center for British Art, Paul Mellon Collection
B1975.4.1155

An amateur naturalist, Alfred Diston made dozens of watercolor drawings, many on the spot, of volcanoes, cliffs, and everyday women and men of the Canary Islands. The islands near the northern coast of Africa had captured the attention of scholars, including German geologist Leopold von Buch (1774–1853) who wrote a book on their climate, flora, and geology, published in 1825.[54] Decades before, on setting out to South America, geologist Alexander von Humboldt (1769–1859) and botanist Aimé Bonpland (1773–1858) visited Tenerife Island and climbed Mount Teide volcano. Humboldt described it in his travel narrative and compared it to Mount Aetna in Sicily.[55]

Diston reportedly was from Lowestoft, Suffolk and came to Tenerife Island in 1810.[56] He may have learned to use watercolor through a manual *The Progress of a Water-Coloured Drawing* published in London in 1812.[57] In 1829 he made this view of Mount Teide with steam floating across the landscape. As written on the *verso*, Diston drew the volcano "from La Estancia de la Sierra, at the entrance of the plain called Las Cañadas. The Medium height of this plain, called by Humboldt that of the Spartium Nubigerum, is by him, estimated at 9800 feet above the level of the sea...."

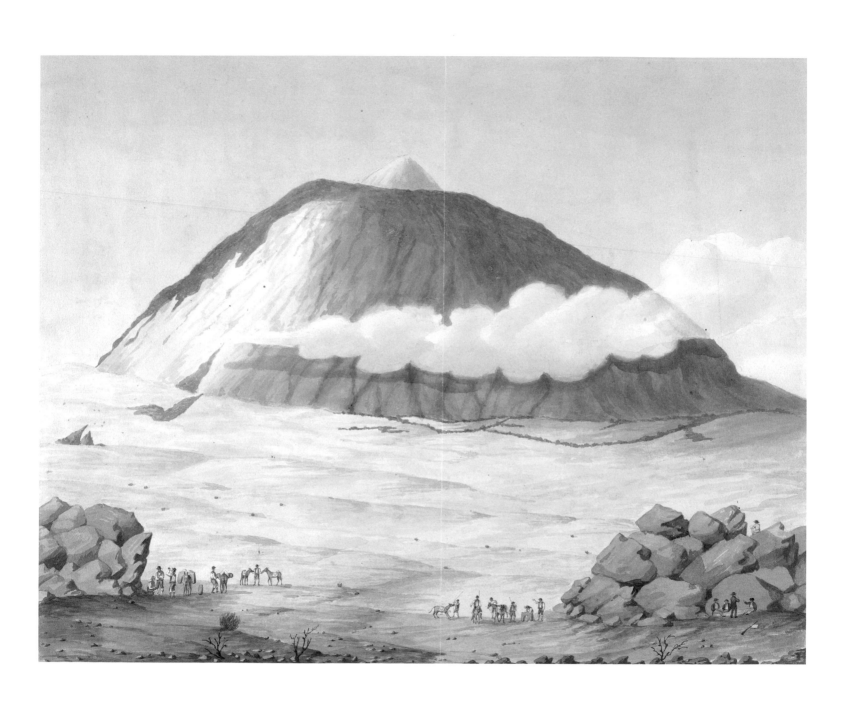

42

CHARLES HAMILTON SMITH
(British, b. Flanders 1776–1859)

Lunar Crater, in *Original Drawings by Lt. Col. Hamilton Smith: Views of Polar Regions*

Watercolor and graphite on moderately thick, moderately textured, cream wove paper
16⅛ × 12⅞ in. (41 × 32.7 cm) (sheet)
Yale Center for British Art, Paul Mellon Collection
71450 - B1978.43.1820(66)
(Vassar only)

Charles Hamilton Smith, a soldier, naturalist, and amateur artist, made several series of drawings that eventually formed a large personal collection guided by his "acquirement of knowledge, of all such facts and objects as could be presented to the mind, by a direct exhibition of pictorial forms...," he stated.[58] With this encyclopedic, research-oriented undertaking, he made around 10,000 drawings, of costumes, ships and vessels, topographical views, and natural history specimens. He noted that about 600 topographical views were rendered directly from nature while others he copied from the sketches of friends, acquaintances in the military, and others. Indeed, he copied several views of the polar regions from sketches he had received from British Royal Navy officers and from prints published in travel journals and books.[59]

Lunar Crater, which appears to portray a volcanic crater, is found in a folio of drawings of the polar regions that includes views of cliffs and icebergs, and copies of illustrations from the travel journal of Sir John Ross (1777–1856). A captain in the Royal Navy, Ross led an expedition into Baffin Bay, along Greenland's southwestern coast, in 1818, searching for a Northwest Passage to the Pacific Ocean.[60]

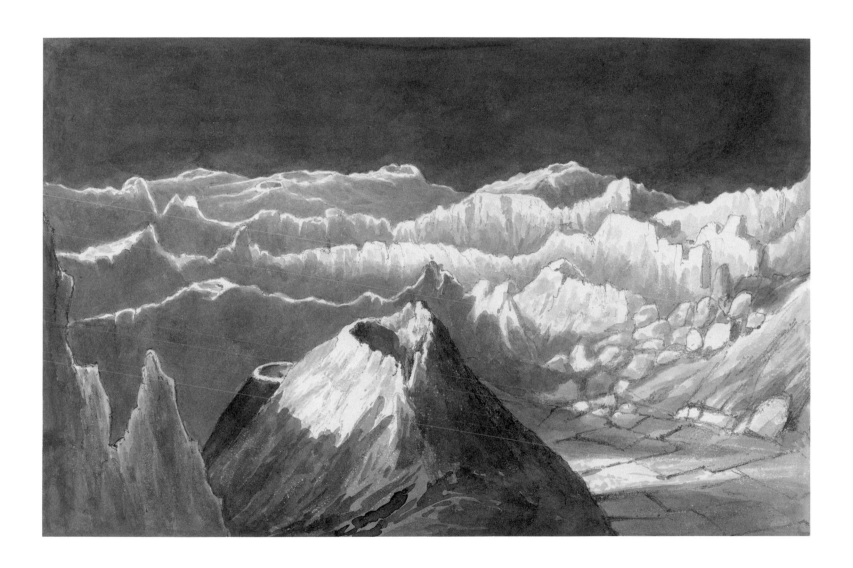

43

CASPAR WOLF
(Swiss 1735–1783)

Alpine Landscape with Two Figures Looking at a Waterfall from under an Umbrella ca. 1773

Watercolor and gouache on thin card
12¼ × 7¹⁵⁄₁₆ in. (31.2 × 20.3 cm.)
Morgan Library & Museum, Thaw Collection
EVT 255

Swiss landscape painter Caspar Wolf was intimately involved with a project that contributed to knowledge about the Swiss Alps during the 1760s and '70s when a large, German-speaking populace was increasingly interested in mineralogy. Bern printer and publisher Abraham Wagner (1734–1782) published books on Swiss glaciers and on mineralogy.[1] Wagner and Wolf, and sometimes Jacob Samuel Wyttenbach (1748–1838), a Swiss natural philosopher and popular writer on the Alps, made tours together in the 1770s into the less accessible areas of the Swiss Alps. In a pioneering step, Wagner had commissioned Wolf to make a series of landscape paintings of the Alps, and the artist made on-site oil sketches and pencil studies in preparation.

From their travels in the Lauterbrunnen Valley, Wagner published a book *Merkwürdige Prospekte aus den Schweizer-Gebürgen* (Remarkable Views of the Swiss Mountains) (1777) featuring ten works by Wolf translated into meticulously rendered, hand-colored etchings of glacier-lined craggy mountains and water-spewing peaks. A foreword by prominent naturalist Albrecht von Haller (1708–1777), author of the widely known poem *Die Alpen*, introduced a first-hand travel account by Wyttenbach.[2] Plates included naturalistic views of waterfalls, including Staubbach Falls, one of the highest in Europe, tumbling almost 1000 feet from a stream springing from limestone cliffs. Though the site depicted in this watercolor is not known, the subject derives from Wolf's deep interest in the alpine natural world and would have had immediate rapport with tourists and patrons.

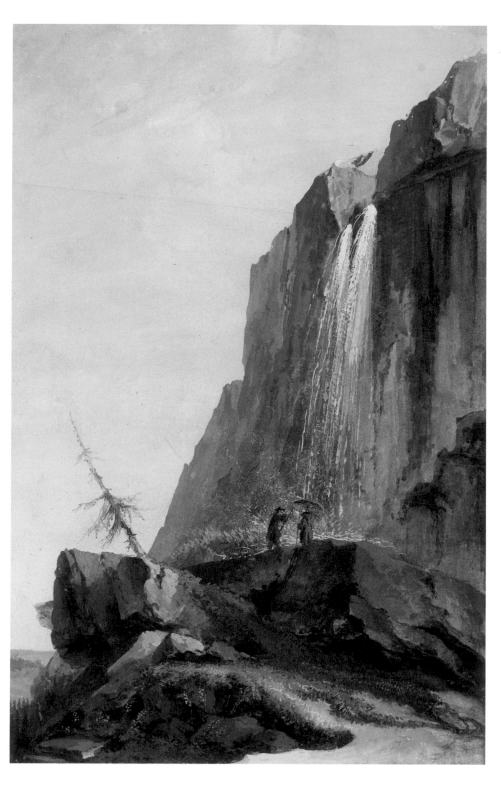

44

JOHANN MORITZ GOTTFRIED JENTZSCH
(German 1759–1826)

Travelers at the Rock Arch in the Limestone Mountains of the River Elbe 1804

Brush and brown ink on wove paper
13¼ × 15¹⁵⁄₁₆ in. (33.7 × 40.5 cm) (sheet)
The Metropolitan Museum of Art, Gift of Dr. Martin Moeller, 2004
2004.82
Image copyright © The Metropolitan Museum of Art
Image source: Art Resource, NY
(Vassar only)

German artist Johann Moritz Gottfried Jentzsch recorded geologically rich landscapes during a time when popular interest in natural science swelled among audiences in northern Europe. In this detailed drawing made in 1804 he rendered tourists visiting the well-known rock gate in Uttewalder Grund, a valley in Saxon Switzerland southeast of Dresden where he lived. Here large rocks are "caught" between two stacked-stone walls of the Elbe Sandstone Mountains. The mountainous region of Saxon Switzerland, named by Adrian Zingg (1734–1816) and Anton Graff (1736–1813), Swiss artists at the Dresden Art Academy, is renowned for unusually shaped rock pillars and multi-layered mountains formed from sand accumulating in an ancient ocean. Jentzsch, a topographical artist whose works show an awareness of Zingg's drawings, drew the sheet for the first volume of *Ansichten der Sächsischen Schweiz in Aberlischer Manier,* presented by Jentzsch and printmaker Johann Gottlob Schumann (1761–1810) in 1805.[3] A contemporary notice for the first volume revealed that Jentzsch drew the four designs included in it after nature.[4]

Jentzsch was a draughtsman, printmaker, and theater set designer born in Hinterjessen, about seventeen miles from Saxon Switzerland. He trained at the Meissen porcelain factory and in 1789 began to work on and issue the much-admired *Ansichten,* for which he gained fame. Success led him to nearby Dresden in 1797 where he settled, thriving there as a set designer for the opera and as a teacher at the Dresden Art Academy.[5]

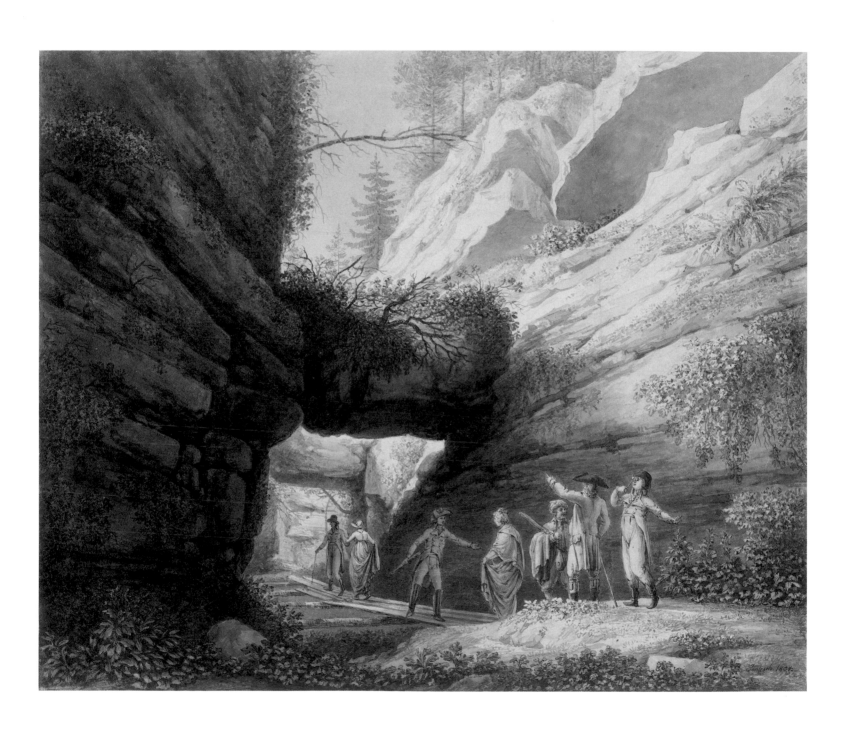

45

CHARLES RÉMOND
(French 1795–1875)

Entrance to the Grotto of Posillipo ca. 1822–42

Oil on paper, laid down on canvas
14 × 9⅞ in. (35.5 × 25.1 cm)
The Metropolitan Museum of Art, The Whitney Collection
Promised Gift of Wheelock Whitney III, and Purchase, Gift of
Mr. and Mrs. Charles S. McVeigh, by exchange, 2003
2003.42.46
Image copyright © The Metropolitan Museum of Art
Image source: Art Resource, NY

The eye-catching cliffs of Posillipo hill and the ancient tunnel carved into it
consist of volcanic rock called Neapolitan yellow tuff.[6] Peter Fabris illustrated
the entrance, after nature, in Sir William Hamilton's *Campi Phlegræi*, the highly
influential folio of 1776 that drew much artistic attention to geological features
near Naples. British ambassador to the Kingdom of Naples and a Fellow of the
Royal Society of London, Hamilton used the local term *tufa* in his text. Deeply
interested in natural history, he illustrated the entrance "to give an idea of the
appearance of the section of a part of a mountain, composed of that sort of
Volcanick substance called Tufa…," he noted.[7]

 In this undated oil sketch by Parisian landscape painter Charles Rémond, the
viewer stands directly in front of the strikingly colored rock walls and plunging,
dark tunnel. Found along a coastal ridge southwest of the city center of Naples,
Posillipo hill became a favorite subject for eighteenth- and early nineteenth-
century artists on their Grand Tours. Drawn to the rocky landscape, Rémond
first drew the attraction in 1822 *en plein air*, enabled by the Prix de Rome in
historical landscape that he had won to study at the French Academy in Rome.[8]

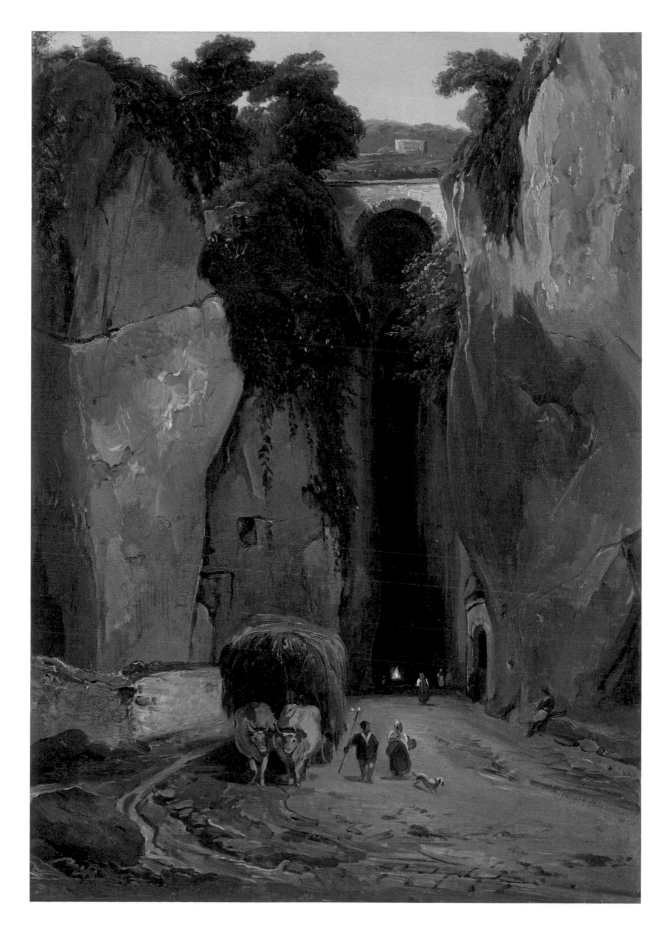

46

JOHN RUSKIN
(British 1819–1900)

Church of the Annunciation at Vico Equense on the Bay of Naples 1841

Watercolor, graphite, ink, and gouache on blue-gray wove paper
15⅝ × 11¼ in. (39.69 × 28.58 cm) (sheet)
Frances Lehman Loeb Art Center, Vassar College
Gift of Matthew Vassar
1864.1.206

On writing in March 1841 about his trek from Sorrento to Vico Equense along the Bay of Naples coast, a youthful John Ruskin noted in his diary, "I never saw a finer thing. It wanted sunlight, and the rocks—tufa—are not of the very best colour or quality but there is a fine gloom about them...," using the local term for the volcanic rock called tuff. "Stopped at Vico to get a sketch, and failed, and bored myself...," he added. The sight of Vico Equense, a town built on volcanic tuff cliffs south of Mount Vesuvius, had riveted his attention days before in late February while riding in a crowded carriage. He had declared in his diary that it was "all lovely rock promontory, orange and olive, and Vico placed *ad captandum—* thoroughly delicious."[9]

These diary entries correspond to Ruskin's drawing of the Church of the Annunciation at Vico Equense. Inspired by the spare drawing style of Scottish painter David Roberts (1796–1864), Ruskin carefully rendered the architecture and rocky cliffs while featuring white highlights against a dark paper, but he departed from the Scotsman in rendering much of the rest sketchily; indeed, the drawing may be unfinished. Executed on a Continental tour with his parents, this picturesque work demonstrates the artist's roots in the widespread topographical style and suggests his earnest and intense curiosity about the natural world. A rock and mineral collector since childhood and a budding geologist, Ruskin was a student of geologist and mineralogist William Buckland at Oxford University. Beyond making geological observations throughout his tour, he also gathered natural specimens from Mount Vesuvius and its environs.[10]

47

JASPER FRANCIS CROPSEY
(American 1823–1900)

Cliff, West Lulworth 1857

Graphite and neutral washes on brown paper, heightened with white gouache
16⁷/₁₆ × 22³/₈ in. (41.8 × 56.8 cm) (sheet)
Museum of Fine Arts, Boston
Gift of Maxim Karolik for the M. and M. Karolik Collection of American
Watercolors and Drawings, 1800–1875
54.1650
Photograph © 2018 Museum of Fine Arts, Boston

The Hudson River School landscape painter Jasper Cropsey drew this robust and
sensitive study of jagged rocks and cliffs near the Dorset village of West Lulworth
in August 1857, during the artist's lengthy stay in Britain in the later 1850s
and early 1860s. With great precision, he pictured the age-old, forceful results
of boulders eroding from a thick, ancient expanse of sedimentary rocks, their
seamed strata easily discerned. Charles Lyell's basic premise on the observable
processes forming the earth's crust is suggested in the fallen rocks pictured in
Cropsey's drawing. The scene is likely from nearby Lulworth Cove, which boasts
numerous cliffs, and to the west of which stands a massive natural arch called
Durdle Door, stretching outward into the English Channel. Cropsey sketched
the arch later on, in October.[11]

 Zigzag rocks and precipitous cliffs were favorite themes of Cropsey and likely
reflect his interest in geology. The American artist had left for London in June
1856 and returned in 1863. In London he became friends with art theorist and
artist John Ruskin (cats. 12, 46) and painter John Brett (cat. 9), both of whom
were deeply engaged with geology.[12] In fact, Ruskin visited Cropsey's Kensington
Gate studio often.[13]

48

WILLIAM TROST RICHARDS
(American 1833–1905)

Land's End, Cornwall ca. 1879–80

Black ink on cardstock
9¾ × 6¼ in. (24.8 × 16 cm) (sheet)
Frances Lehman Loeb Art Center, Vassar College
Gift of Ellen G. Milberg, class of 1960, in honor of Patricia Phagan
2017.45.4

American artist William Trost Richards made several images of Land's End, a rocky headland found in Cornwall at the western tip of the peninsula stretching toward the confluence of the English and Bristol Channels. This muscular drawing with its networks of nervous lines shows the artist's great interest in the exposed rock columns of the magnificent cliffs found there. Their sun-struck granite pillars, jointed and cracked, had survived the lashing, eroding effects of tumultuous waves and winds. The formations made Land's End a subject for travel literature and print series such as *Picturesque Views on the Southern Coast of England*, published in 1826 with engravings after drawings by J. M. W. Turner.[14]

Richards would travel to Land's End in summer 1879 with his brother-in-law "to complete some studies for a picture I have in my mind," he wrote.[15] He stayed for several days in September, and Richards exclaimed, "I thought I would never be equally interested in any other rocky coast...."[16] The design of the present drawing appears to be a preparatory study for his subsequent painting *Land's End* (unlocated), which was painted in 1880 and described by a critic of the time as "a geological study...an effort to paint crevice by crevice all the rocks of a coast."[17]

Wm. T. Richards

Lands End Cornwall

49

WILLIAM TROST RICHARDS
(American 1833–1905)

Legendary England: Tintagel 1882

Watercolor, touches of gouache, and graphite on cream wove paper
9¾ × 15¾ in. (24.77 × 40.01 cm) (sheet)
Frances Lehman Loeb Art Center, Vassar College
Gift of Elias Lyman Magoon
1883.2.2

The astonishing close-up clarity in the slate rocks found in this watercolor by
William Trost Richards demonstrates the artist's profound commitment to a
direct study of nature. Minutely detailed, the watercolor suggests the American
Pre-Raphaelite devotion to painting or drawing exactly what one sees outdoors
in nature, and with "the perfection of the minutiae," as art critic Henry
Tuckerman wrote of Richards in 1867.[18] Richards, a member of the American Pre-
Raphaelites, shows here the influence of John Ruskin, the deeply influential mid-
nineteenth century thinker and critic who was also an amateur geologist and
artist (cats. 12, 46). The theorist believed that the more lifelike a painter rendered
nature the closer he or she was to reaching a higher truth, and he championed
geology as key to preparing the way.

Richards painted Tintagel several times and he observed the "fierce
distortions" of its slate and the "sheer precipice 300 ft high...."[19] Located on
the northern coast of Cornwall, the Tintagel headland reaches into the Bristol
Channel, and the ruins on its summit are said to be the birthplace and home of
King Arthur. The American art collector, minister, and author Dr. Elias Lyman
Magoon (1810–1886), a key patron of Richards, commissioned this watercolor as
part of a landscape series devoted to English culture, history, and commerce.[20]

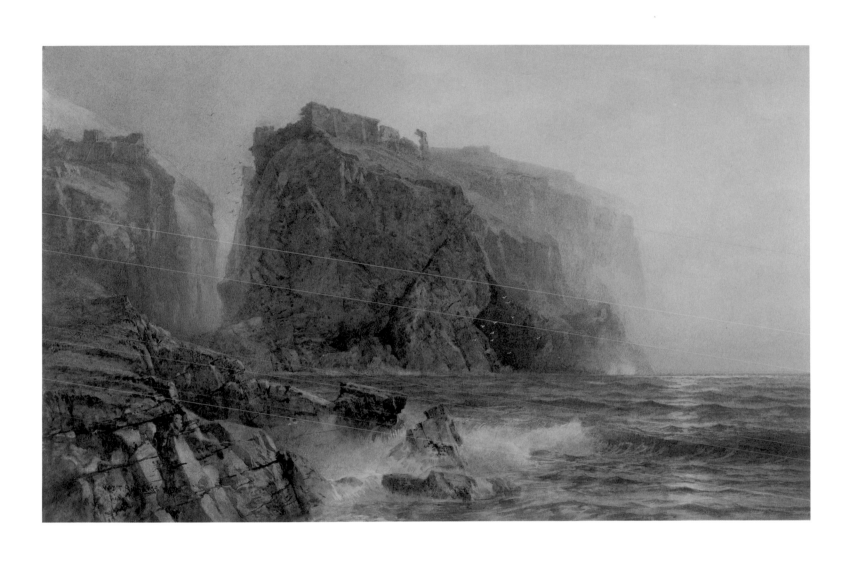

50

FREDERIC CHURCH
(American 1826–1900)

Cliffs and Rocky Cove, Mount Desert Island
ca. August 1850

Oil on light brown cardboard
12⅛ × 16⅛ in. (30.8 × 41 cm)
Collection Olana State Historic Site, Hudson, NY, New York State Department of Parks,
Recreation and Historic Preservation
OL.1978.22

The Hudson River School painter Frederic Church explored landforms globally,
travelling in the Americas, Europe, the Middle East, and the polar regions,
sketching geological features that interested him. Indeed, chronicler Henry
Tuckerman claimed that Church painted "with the fidelity of a naturalist."[21]
Mount Desert Island, off the coast of Maine, has long been recognized as a
natural geological wonder, formed by tectonic uplifting of mountains and
slow carving by moving glaciers during the past 500 million years.[22] Artists in
particular have favored the rocky landforms of Cadillac Mountain, Otter Cliffs,
and Monument Cove. Thomas Cole, Church's teacher during the mid-1840s,
made pencil sketches in summer 1844 documenting several locales.

In August 1850 Church rendered graphite topographical drawings and oil
sketches of coastline rocks and cliffs of the island. This head-on view of rocks,
resembling Otter Cliffs, depicts meandering seams coursing through their
angular, jagged, and slowly weathering layers.[23] Anchoring a sandy cove, they
lunge forward, crowd one another, and almost block the sky, while luxuriant
vegetation breathes atop. With its suggestion of meticulously rendered erosion,
the work reflects the popular theories of British geologist Charles Lyell who
asserted the idea of slow and uniform changes on earth, as well as the "truth to
nature" mandate of John Ruskin. The widely influential artist, art theorist, and
amateur geologist valued a factual representation of nature as prerequisite to the
idea of truth.

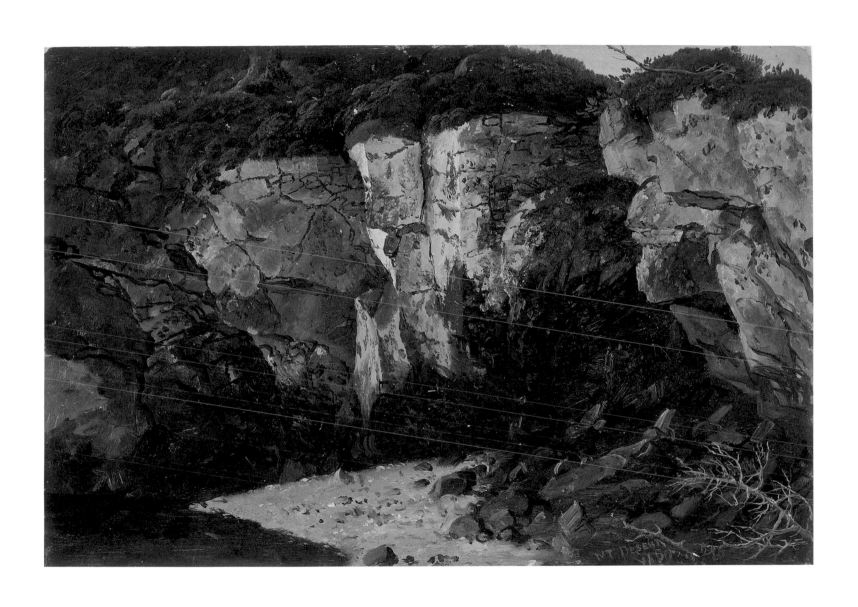

51

JERVIS McENTEE
(American 1828–1891)

Bald Porcupine, 1864,
from the Maine and New York Sketchbook 1864–65

Graphite and white chalk on cream wove paper
10¼ × 6⅛ in. (26.04 × 15.56 cm) (page in sketchbook)
Frances Lehman Loeb Art Center, Vassar College
Gift of William E. Gaffken in memory of Barbara Rodie Shultz, class of 1942
1996.25.3.2

Jervis McEntee made a handful of drawings from an excursion to Mount Desert Island, Maine, in a sketchbook of 1864–65. With its interestingly shaped glacial rock formations, the island attracted generations of painters in the nineteenth century. Using pencil and white chalk, McEntee carefully recorded the rocky topography of Schooner Head and nearby Bald Porcupine Island and scattered rocks along the beaches, using weighted contour lines and shading to document the geological features that attracted him.

McEntee traveled to Mount Desert Island in July 1864 and worked there with fellow Hudson River School artist and geology enthusiast Sanford Robinson Gifford (cats. 18, 19, 28, 29).[24] McEntee seems to have been particularly drawn to Bald Porcupine Island, a small land mass situated immediately off of the eastern coast of Mount Desert Island. He made two drawings featuring the cliffs that skirt the island. This more dramatic view, dated July 26, accentuates the sheer cliffs with their sun-struck array of rock in the form of a tabular body of igneous (magma-hardened) materials. The same day Gifford drew the scene in pencil from very close to the same vantage point.[25]

Bald Porcupine
July 26 1864 —

1996.25.3.2

52

FREDERIC CHURCH
(American 1826–1900)

Horseshoe Falls and Table Rock ca. 1856–57

Oil on canvas
17⅝ × 11⅝ in. (44.8 × 29.5 cm)
Collection Olana State Historic Site, Hudson, NY, New York State Office of Parks,
Recreation and Historic Preservation
OL.1981.9.A.B

Niagara Falls, bordering the United States and Canada, is one of the most recognizable geological features of North America. The monumental canvas picturing this site, *Niagara* (1857, Corcoran Collection, National Gallery of Art), by Frederic Church propelled American landscape into the international spotlight in the middle of the nineteenth century. Church visited Niagara and its curved Horseshoe Falls on the Canadian side in 1856. By December and January, he had painted this oil study of the site of Table Rock at Horseshoe Falls.[26] However, by this time the long, horizontal ledge, which was a favorite perch for tourists, had been broken off by the fast-moving water.

In this closely painted study, the salmon-colored, putty-like stone of the Table Rock remnant caps a cliff richly layered in dark, shaley rocks. In a daring move capturing an immediate sense of the all-consuming power of nature, Church placed himself just out of reach of the battered cliff. The foamy sea-green rim of Horseshoe Falls materializes beyond, launching water violently downward into a white mist.[27] The ferocity of the water and subsequent erosion reflect a direct view of geological processes at work in shaping the earth's crust. This would have appealed to Church's already robust interest in geology, inherited from Thomas Cole, his mentor, renewed by reading Alexander von Humboldt's *Cosmos* and travel journals, and deepened by traveling on his own expedition to Ecuador in 1853.[28]

NOTES TO THE ENTRIES

1: CAVES AND NATURAL ARCHES

1. Jenny Uglow, *The Lunar Men: Five Friends Whose Curiosity Changed the World* (New York: Farrar, Straus and Giroux, 2002), 138–53.
2. John Whitehurst, *Inquiry into the Original State and Formation of the Earth* (London: Printed for the author, and W. Bent, by J. Cooper, 1778); Maxwell Craven, *John Whitehurst of Derby: Clockmaker and Scientist 1713–88* (Ashbourne, Derbyshire: Mayfield Books, 1996), 95; David Fraser, "'Fields of radiance': The Scientific and Industrial Scenes of Joseph Wright," in *The Iconography of Landscape*, ed. Denis Cosgrove and Stephen Daniels (Cambridge: Cambridge University Press, 1988), 126–27.
3. Inge Feuchtmayr, *Johann Christian Reinhart 1761–1847* (Munich: Prestel Verlag, 1975), 57–8.
4. F. Carlo Schmid, "'[...] da mein ganzes Vermögen meine Hände und Kopf sind.' Johann Christian Reinhart als Zeichner und Radierer," in *Johann Christian Reinhart: Ein deutscher Landschaftsmaler in Rom* (Munich: Hirmer, 2012), 10.
5. Ibid., 11–12, where Schmid discusses this drawing.
6. Johann Friedrich Esper, *Ausführliche Nachricht von neuentdeckten Zoolithen unbekannter vierfüsiger Thiere* (Nuremberg: Georg Wolfgang Knorrs Seel. Erben, 1774). See also Martin J. S. Rudwick, *Bursting the Limits of Time* (Chicago and London: University of Chicago Press, 2005), 272–73.
7. Nelly Colin, "Jean-Claude Bonnefond et l'Italie," *Lyon et l'Italie: six études d'histoire de l'art*, ed. Daniel Ternois (Paris: Editions du Centre National de la Recherche Scientifique, 1984), 213–15.
8. Grant Heiken, ed., *Tuffs: Their Properties, Uses, Hydrology, and Resources*, Special Paper 408 (Boulder, CO: Geological Society of America, 2006), ii.
9. The dating is cited in Roberta J. M. Olson, *Drawn by New York* (New York: New-York Historical Society; and London: D Giles Limited, 2008), 185.
10. On the geology of Dover Plains, see David Robert Waldbaum, "Stratigraphy and Structural Relations of the Carbonate Rocks in the Dover Plains, N.Y., Quadrangle," Senior Thesis, Massachusetts Institute of Technology, 1960.
11. Thomas Cole to Asher B. Durand, 23 June 1836, Asher B. Durand Papers, Archives of American Art, Roll N19, frame 1051. On the early science of shells, see Thomas Brown, *The Conchologist's Textbook*, 4th ed. (Glasgow: Archibald Fullarton and Co., 1836).
12. William Hauptman, *John Webber 1751–1793* (Bern and Manchester: Kunstmuseum Bern and Whitworth Art Gallery, University of Manchester, 1996), 13–4, 29, 32.
13. Ibid., 53.
14. For the trip to Derbyshire, see especially ibid., 193–214. The arch is not far from the Dove Holes that Wright of Derby pictured, see cat. 1.
15. On Day, see J. E. Egerton, "William Day 1764–1807," *Connoisseur* 174 (1970): 176–85.
16. Sir Harry Johnston et al, *The Wonders of the World* (New Delhi: Logos Press, 2004), 766.
17. Leonora Cranch Scott, *The Life and Letters of Christopher Pearse Cranch* (Boston and New York: Houghton Mifflin, 1917), 146–48.
18. Linda S. Ferber, "William Trost Richards (1833–1905): American Landscape and Marine Painter," Ph.D. diss., Columbia University, 1980, 5–6.
19. W. T. Richards to James Mitchell, Philadelphia, 29 October 1854, in ibid., 107.
20. Ibid., 61.
21. Ibid., 132–42.
22. Christiana Payne, *John Brett, Pre-Raphaelite Landscape Painter* (New Haven and London: Yale University Press for the Paul Mellon Centre for Studies in British Art, 2010), 17, 25–26.
23. See ibid., 32–33, especially Brett's diary entry, 9 December 1856, cited on 33; and Allen Staley, *The Pre-Raphaelite Landscape*, 2nd ed. (New Haven: Yale University Press, 2001),
169–72. "Fine Arts: Royal Academy," *Athenaeum* (16 May 1857): 633.
24. Payne, *John Brett*, 165, 234 (no. 1269).
25. "Kynance Cove," www.geolsoc.org.uk/GeositesKynance.
26. My thanks to Jill Schneiderman for this observation.

2: ROCKS AND ROCK FORMATIONS

1. *Interesting Selections from Animated Nature, with Illustrative Scenery: Designed and Engraved by William Daniell, A. R. A.* (London: T. Cadell and W. Davies, 1807–09), 2 vols.
2. Matthew Payne and James Payne, *Regarding Thomas Rowlandson* (London: Hogarth Arts, 2010), 150–51, 176–78, 252–54, 281, 303, 305, 340.
3. See the Thomas Rowlandson Collection at the Isle of Wight Council Museum of Island History, www.iwight.com, particularly the drawings of Shanklin and Freshwater.
4. See Thomas Jones, "Memoirs of Thomas Jones: Penkerrig Radnorshire," *Walpole Society* 32 (1946–48): 1–143. On Jones, see Ann Sumner and Greg Smith, eds., *Thomas Jones* (New Haven and London: Yale University Press, in association with National Museums and Galleries of Wales, 2003).
5. "Memoirs of Thomas Jones," 61.
6. Michael Reed, *The Landscape of Britain: From the Beginnings to 1914* (Savage, MD: Barnes and Noble Books, 1990), 8–9.
7. Dr. Gilby Jun., "Account of the Trap and Clay-slate Formation Extending from Llandegly to Builth in Brecknockshire," *Edinburgh Philosophical Journal* II (January–April 1820): 256.
8. E. T. Cook and Alexander Wedderburn, *The Works of John Ruskin*, vol. 1 (London: George Allen, 1903), xxv.
9. J. R., "Facts and Considerations on the Strata of Mont Blanc," *Magazine of Natural History* 7 (December 1834): 644–45.
10. John Ruskin, *Modern Painters*, vol. 4 (London: Smith, Elder,
and Company, 1856).
11. Cited in David and Francina Irwin, *Scottish Painters at Home and Abroad 1700–1900* (London: Faber and Faber, 1975), 293. This catalogue entry is largely based on the Irwins' account.
12. See Michael Clarke, *Poussin to Seurat* (Edinburgh: National Galleries of Scotland, 2010), no. 40, for a brief biography.
13. N. Al. Michel Mandevare, *Principes raisonnés du paysage à l'usage des écoles des Départemens de l'Empire français, dessinés d'après nature* (Paris: M. Boudeville, 1804), "Explication des Principes Contenus dans le Sixième Cahier," n.p.
14. The work comes from a sketchbook with drawings made by Wright on his Continental trip with additional drawings by his student Richard Hurleston, which was sold at Sotheby's on July 20, 1966, lot 209.
15. Joseph Wright to Richard Wright, Rome, 11 November 1774, in Elizabeth E. Barker, "Documents Relating to Joseph Wright 'of Derby' (1734–97)," *Walpole Society* 71 (2009): 84.
16. Whitehurst, *Inquiry*, Appendix, 145. See also Fraser, "'Fields of radiance,'" 124–9; and Andrew Graciano, "'The Book of Nature is Open to All Men'; Geology, Mining, and History in Joseph Wright's Derbyshire Landscapes," *Huntington Library Quarterly* 68, no. 4 (2006): 587–90.
17. Claudia Nordhoff, "Jakob Philipp Hackert. Leben und Werk," *Jakob Philipp Hackert: Europas Landschaftsmaler der Goethezeit* (Hamburg: Hamburger Kunsthalle; Weimar: Klassic Stiftung Weimar, 2008), 11. Mitchell, *Art and Science*, 14.
18. Durand bought two boxes of agate, a volcanic rock, in the French Alps during travel in Europe. Asher B. Durand Journal, 1 June 1840, p. 145, AAA Durand Papers, Roll N20.
19. David B. Lawall, *Asher B. Durand: A Documentary Catalogue of the Narrative and Landscape Paintings* (New York and London: Garland Publishing, 1978): no. 350, 175–76, 169.

20. John Durand to Asher B. Durand, 22 August 1844, AAA Durand Papers, Roll N20, frame 201.

21. Caroline Durand to John Durand, 24 September [1857], AAA Durand Papers, Roll N20, frames 1018–21; Hugh Miller, *The Old Red Sandstone* (Edinburgh: John Johnstone, 1841).

22. Asher B. Durand to John Durand, 14 October 1859, AAA Durand Papers, Roll N20, frame 1081.

23. An early work is *Kauterskill Lake*, 1845, 16½ × 12 in., *A Memorial Catalogue of the Paintings of Sanford Robinson Gifford, N.A.* (New York: Metropolitan Museum of Art, 1881), no. 1, p. 13.

24. "Jervis McEntee's Diary," *Archives of American Art Journal* 8, nos. 3–4 (July–October 1968): 1.

25. These are reprinted in Linda S. Ferber, ed., *Kindred Spirits: Asher B. Durand and the American Landscape* (Brooklyn, NY: Brooklyn Museum; London: D Giles Limited, 2007), 231–52.

26. David King, *An Historical Sketch of the Redwood Library and Athenaeum, in Newport, Rhode Island* (Boston: John Wilson and Son, 1860), iii.

27. Sally Mills, "John Frederick Kensett," in Ella M. Foshay and Sally Mills, *All Seasons and Every Light* (Poughkeepsie: Vassar College Art Gallery, 1983), 69. E. L. Magoon, *Westward Empire* (New York: Harper and Brothers, 1856), v, 323, 363–64, 383, 413.

28. Frederic E. Church to Erastus Dow Palmer, Jaffa, 10 March 1868. Courtesy of Albany Institute of History and Art, McKinney Library, Erastus Dow Palmer Papers. Copy in Research Collection, Olana State Historic Site, Hudson, NY, New York State Office of Parks, Recreation and Historic Preservation.

29. Ibid.

30. Gerald L. Carr, *Frederic Edwin Church: Catalogue Raisonné of Works of Art at Olana State Historic Site*, vol. 1 (Cambridge: Cambridge University Press, 1994), no. 466, 318–19.

3: MOUNTAINS, GLACIERS, AND VOLCANOES

1. S. Palmer to Mr. L. R. Valpy, May 1875, in A. H. Palmer, *The Life and Letters of Samuel Palmer* (London: Seeley and Co., Limited, 1892), 357.

2. Several of these watercolors are in the collection of the Yale Center for British Art.

3. Samuel Palmer to George Richmond, Tintern Abbey, Monmouthshire, 19 August 1835, in Raymond Lister, ed., *The Letters of Samuel Palmer*, vol. 1 (Oxford: Clarendon Press, 1974), 71.

4. On this treatise see especially Kim Sloan, *Alexander and John Robert Cozens: The Poetry of Landscape* (New Haven and London: Yale University Press; published in association with the Art Gallery of Ontario, 1986), 50–55.

5. On Knight see Michael Clarke and Nicholas Penny, eds., *The Arrogant Connoisseur: Richard Payne Knight 1751–1824* (Manchester: Manchester University Press, 1982).

6. Sloan, *Cozens*, 121. See also Andrew Wilton, *The Art of Alexander and John Robert Cozens* (New Haven: Yale Center for British Art, 1980), no. 95, 42–43; and Christopher White, *English Landscape* (New Haven: Yale Center for British Art, 1977), no. 71.

7. Andrew Wilton, *J. M. W. Turner: His Art and Life* (Secaucus, NJ: Poplar Books, 1979), no. 1480, 474, 477–78. On the Axenberg cliffs, see John Ball, *The Central Alps*, new ed. (London: Longmans, Green, and Co., 1873), 156.

8. Joseph Wilson, *A History of Mountains*, vol. 2 (London: Messrs. Nicol et al, 1809), 261.

9. *Cook's Tourist's Guidebook for Switzerland* (London: Thos. Cook and Son, 1908), 103.

10. James Hamilton, *Turner and the Scientists* (London: Tate Gallery Publishing, 1998), 115–26; John Gage, *J. M. W. Turner: 'A Wonderful Range of Mind'* (New Haven and London: Yale University Press, 1987), 218–22.

11. S. R. Gifford to Father, Paris, dated 4 February 1856, journal entry of 4 February 1856, 167, Sanford Robinson Gifford Papers, Archives of American Art, Smithsonian Institution. Perhaps the geologist was Robert Pinchin (1821–1888), member of the Geological Society of London.

12. Ibid., Bellagio, Lago di Como, dated 24 August 1856, journal entry of 16 August 1856, 90, AAA Gifford Papers.

13. *A Memorial Catalogue*, 20, no. 158. See Ila Weiss, "Sanford Robinson Gifford (1823–1880)," Ph.D. diss., Columbia University, 1968, 163–64.

14. *A Memorial Catalogue*, 17, no. 95, *A Sketch of Isola dei Pescatori, Lago Maggiore*, 7½ × 10 in. See Weiss, 165–67.

15. *A Memorial Catalogue*, 20, no. 170, titled *Lago Maggiore, A Study*.

16. See Carr, *Frederic Edwin Church: Catalogue Raisonné*, vol. 1, 325–36.

17. Ibid., 326–27 (entry for no. 476, *Königssee, Germany*, an oil sketch, OL.1980.1885 [P558]).

18. Ibid., vol. 1, nos. 474 and 476.

19. Bettina Hausler, "'Auf verdammt beschwerlichen Bergwegen': Carl Morgensterns Reisen in die Schweiz," in *Carl Morgenstern und die Landschaftsmalerei seiner Zeit* (Frankfurt am Main: Museum Giersch, 2011), 201.

20. "Nachmittag auf die Wengernalp, wo man der Jungfrau und den grossen Gletschern gegenüber ist...," from a letter from Morgenstern to Louise Morgenstern, dated 24 August 1851, quoted in Hausler, 207.

21. A team led by Agassiz climbed the Jungfrau in 1841. See E. Desor, "Ascent of the Jungfrau," *Edinburgh New Philosophical Journal* 32 (April 1842): 291–333.

22. Frank Maclean, *Henry Moore R.A.* (London: Walter Scott Publishing Co., Ltd.; New York: Charles Scribner's Sons, 1905), 27–29.

23. Ibid., 29–30.

24. See Stephen D. Rubin, *John Singer Sargent's Alpine Sketchbooks* (New York: Metropolitan Museum of Art, 1991); and Stephanie L. Herdrich and H. Barbara Weinberg, *American Drawings and Watercolors in The Metropolitan Museum of Art: John Singer Sargent* (New York: Metropolitan Museum of Art, 2000), 41–43, 49–99 (17qq recto, p. 97).

25. Evan Charteris, *John Sargent* (New York: Charles Scribner's Sons, 1927), 10. See the register of the Düsseldorf Art Academy, Findbuch 212.01.04 Schülerlisten der Kunstakademie Düsseldorf, Regierung Düsseldorf Präsidialbüro, Landesarchiv Nordrhein Westfalen, http://www.archive.nrw.de [p. 203], where Carl Welsch is listed in the Landscape class for the study year 1846.

26. Cynthia Gamble, "John Ruskin, Eugène Viollet-le-Duc and the Alps," *Alpine Journal* (1999): 190.

27. E. Viollet-le-Duc, *Le Massif du Mont Blanc* (Paris: Librairie Polytechnique, 1876). According to the author, "je m'etais donné la tâche de dresser la carte complète de ce massif à une échelle assez grande pour me permettre d'y marquer aussi fidèlement que possible la forme et la disposition des roches cristallines et des terrains qui le composent," vii–viii.

28. Inscribed on recto "Lac du col sur l'aig. Pourrie 7 aout 74."

29. Gamble, "John Ruskin, Eugène Viollet-le-Duc and the Alps," 190. See also Paula Young Lee, "'The Rational Point of View': Eugène-Emmanuel Viollet-le-Duc and the *camera lucida*," in *Landscapes of Memory and Experience*, ed. Jan Birksted (London: Spon Press, 2000), 63–73.

30. "Isaac Weld, Esq., M.R.I.A., Vice-President of the Royal Dublin Society, etc., etc.," *Dublin University Magazine* 49 (Jan.–June 1857): 74.

31. Cited in G. L. Herries Davies, *Sheets of Many Colours: The Mapping of Ireland's Rocks, 1750–1890* (Dublin: Royal Dublin Society, 1983), 6.

32. "Isaac Weld, Esq." 77. For a later biography, see Thomas Seccombe, rev. by Elizabeth Baigent, "Isaac Weld," *Oxford Dictionary of National Biography*, www.oxforddnb.com.

33. Asher B. Durand Journal, 1 June 1840, 1, Durand Papers, Archives of American Art, Roll N20.

34. Ibid., 16 June 1840, 10.

35. Ibid., 11.

36. Ibid., 10 September 1840, 134–35.

37. Asher B. Durand to Mary Durand, Rome, 6 March 1841, AAA Durand Papers, Roll N20.

38. Durand to Jonathan Sturges, 1 April 1841, part 3.12, quoted in Barbara Dayer Gallati, "'A Year of Toilsome Exile,' Asher B. Durand's European Sojourn," in Ferber, ed., *Kindred Spirits*, n. 100, 125.

39. Thomas Cole, "Sicilian Scenery and Antiquities," *The Knickerbocker* 23, no. 2 (February 1844): 112.

40. See Rebecca Bedell, "Thomas Cole and the Fashionable Science," *Huntington Library Quarterly* 59, nos. 2 and 3 (1996): 349–78; and Novak, *Nature and Culture*, 51–52.

41. See Samuel L. Metcalf, "The Interest and Importance of Scientific Geology as a Subject for Study," *The Knickerbocker* 3 (April 1834): 227.

42. *An Exhibition of Paintings by Thomas Cole N.A. from the Artist's Studio, Catskill, New York* (New York: Kennedy Galleries, Inc., 1964), 12. See also Franklin Kelly, "Myth, Allegory, and Science: Thomas Cole's Paintings of Mount Etna," *Arts in Virginia* 23 (1983): 3–17.

43. See the National Park Service website: www.nps.gov/yell/learn/nature/geology.htm.

44. "An Artist's Rambles," *New York Express*, 28 October 1881, 61–62, Rosalie Osborne Mayer scrapbook, cited in Richard Shafer Trump, "Life and Works of Albert Bierstadt," Ph.D. diss., Ohio State University, Columbus, 1963, 188, n. 1.

45. "An Artist's Rambles," 62.

46. "An Artist's Rambles," quoted in Gordon Hendricks, *Albert Bierstadt: Painter of the American West* (Fort Worth: Amon Carter Museum of Western Art; New York: Harry N. Abrams, Inc., 1974), 267.

47. See especially Fitz Hugh Ludlow's geologically rich text on his and

Bierstadt's 1863 trip out West in *The Heart of the Continent* (New York: Hurd and Houghton, 1870).

48. See especially nos. 232–36, in Anne Morand, *Thomas Moran: The Field Sketches, 1856–1923* (Norman and London: University of Oklahoma Press, 1996), 146–47.

49. Ibid., 14–17, 106–07 (nos. 14–16). On this, see also Nancy K. Anderson, *Thomas Moran* (Washington, D.C.: National Gallery of Art; New Haven and London: Yale University Press, 1997), 26–27.

50. Carr, *Frederic Edwin Church: Catalogue Raisonné*, vol. 1, no. 385, 245–46.

51. Frederic Church, Sangay diary, 1857, 12, 32–33, 41–43, OL.1980.28; and the edited and expanded version (ca. 1890s), "A Trip to the Volcano Sangai in Equador," OL.2001.4567.A–.M, 2–3, 8. See also letter from F. E. Church to A. C. Goodman, 24 June 1857, OL.1983.1070, Olana State Historic Site, Hudson, NY, New York State Office of Parks, Recreation and Historic Preservation.

52. See "Copy of Books in Church's Library at Olana," Olana State Historic Site.

53. Alexander von Humboldt, *Cosmos*, vol. 2 (London: Henry G. Bohn, 1849), 452–53.

54. Leopold von Buch, *Physicalische Beschreibung der canarischen Inseln* (Berlin: Königlichen Akademie der Wissenschaften, 1825).

55. Alexander von Humboldt and Aimé Bonpland, *Personal Narrative of Travels to the Equinoctial Regions of the New Continent, during the Years 1799–1804*, vol. 1, trans. Helen Maria Williams (London: Longman et al, 1814), 101, 201–02.

56. "Portrait of an English Merchant Forgotten: Alfred Diston," www.tenerifenews.com, accessed January 15, 2018.

57. John Laporte, *The Progress of a Water-Coloured Drawing* (London: James Whiting, 1812), cited in Juan Tous Meliá, *La medida del Teide*, 2nd ed. (San Cristóbal de la Laguna: Publidisa, 2015), 229.

58. "An Account of the Collection of Drawings of Major Hamilton Smith, F.R.S. F.L.S., &c. &c. &c. and Member of the Plymouth Institution, in a Letter to the President," *Transactions of the Plymouth Institution* (Plymouth: Rowe, 1830), 256. On Smith, see Christine

E. Jackson, "Charles Hamilton Smith," *Oxford Dictionary of National Biography*, www.oxforddnb.com.

59. "An Account of the Collection of Drawings of Major Hamilton Smith," 284–85.

60. Sir John Ross, *A Voyage of Discovery, Made Under the Orders of the Admiralty, in His Majesty's Ships Isabella and Alexander, for the Purpose of Exploring Baffin's Bay, and Inquiring into the Probability of a North-West Passage* (London: John Murray, 1819).

4: CLIFFS

1. For example, Gottlieb Sigmund Gruner, *Die Eisgebirge des Schweizerlandes*, 3 vols. (Bern: Abraham Wagner, Sohn, 1760); idem, *Die Naturgeschichte* (Bern: Abraham Wagner, 1773).

2. Jacob Samuel Wyttenbach, *Merkwürdige Prospekte aus den Schweizer-Gebürgen und derselben Beschreibung* (Bern: Wagner, 1777), 1, in Bayerische Staatsbibliothek Bildähnlichkeitssuche, https://bildsuche.digitale-sammlungen.de. See Katharina Georgi, "The Alpine Project: *Merkwürdige Prospekte aus den Schweizer-Gebürgen* and the 'Wagner Cabinet,'" in *Caspar Wolf and the Aesthetic Conquest of Nature* (Basel: Kunstmuseum Basel, 2014), 98–101.

3. See the corresponding print, "Das Thor im Ottowalder Grunde," aquatint and etching, in the Kupferstich-Kabinett, Staatliche Kunstsammlungen Dresden, A 1995–6808.

4. Anonymous, *Abend-Zeitungs Intelligenzblatt für Literatur und Kunst* (2 March 1805), [2].

5. G. K. Nagler, *Neues Allgemeines Künstler-Lexicon*, vol. 6 (Munich: Verlag E. A. Fleischmann, 1838), 441–42.

6. A. Aversa, A. Evangelista, and A. Scotto di Santolo, "Influence of the Subsoil on the Urban Development of Napoli," in *Geotechnical Engineering for the Preservation of Monuments and Historic Sites*, ed. Emilio Bilotta et al (Boca Raton, FL: CRC Press, 2013), 21, see Fig. 15a.

7. Hamilton, *Campi Phlegræi*, text to Plate XVI.

8. École nationale supérieure des Beaux-Arts, Paris. See the catalogue entry *Entrance to the*

Grotto of Posillipo by Asher Ethan Miller, www.metmuseum.org/art/collection. See also Suzanne Gutwirth, "Jean-Charles-Joseph Rémond (1795–1875), Premier Grand Prix de Rome du Paysage historique," *Bulletin de la Société de l'Histoire de l'Art français* (1983): esp. no. 110. Rémond also painted a more conventional oil sketch of the site (Musée Bonnat, Bayonne).

9. Journal entries, 26 February, 1 March 1841, in Joan Evans and John Howard Whitehouse, eds., *The Diaries of John Ruskin* (Oxford: Clarendon Press, 1956), 157–59.

10. Ibid., 157, n. 1.

11. *Durdle Door, West Lulworth*, 1857, graphite on tan paper, 7⅞16 × 12⅜ in. (19 × 31.5 cm), Newington-Cropsey Foundation, Hastings-on-Hudson, NY.

12. *Jasper F. Cropsey 1823–1900* (Washington, D.C.: National Collection of Fine Arts, Smithsonian Institution, 1970), 30.

13. Noted by Peter Bermingham in his text for *Jasper F. Cropsey (1823–1900)* (College Park: University of Maryland Art Gallery, 1968), 27, n. 17.

14. *Land's End, Cornwall*, designed by J. M. W. Turner, engraved by George Cooke, in *Picturesque Views on the Southern Coast of England*, vol. 2 (London: John and Arthur Arch et al, 1826), no. 70.

15. W. T. Richards to George Whitney, Wyke Regis, Dorset, 1 August 1879, in Ferber, "William Trost Richards," 317.

16. W. T. R. to Charles Matlack, Padstow, Cornwall, 17 September 1879, William Trost Richards Papers, Archives of American Art, Box 1, folder 2, 34.

17. "The Whitney Collection," (New York) *Evening Post*, 9 December 1885, cited in Ferber, "William Trost Richards," 320.

18. Henry T. Tuckerman, *Book of the Artists: American Artist Life* (New York: G. P. Putnam & Son, 1867), 524.

19. W. T. Richards to George Whitney, London, 18 December 1878, in Ferber, "William Trost Richards," 322.

20. The series is entitled "Cycle of Universal Culture Illustrated by the Graphic History of English Art." See Ferber, "William Trost Richards," 332. The series of watercolors are

in the permanent collection of the Frances Lehman Loeb Art Center.

21. Tuckerman, *Book of the Artists*, 372.

22. On the geology of Mount Desert Island, see Richard A. Gilman, et al., *The Geology of Mount Desert Island* (Augusta: Maine Geological Survey, Department of Conservation, 1986).

23. Carr, *Frederic Edwin Church: Catalogue Raisonné*, vol. 1, no. 274, 179. See John Wilmerding, *Maine Sublime* (Hudson, NY: Olana Partnership; Albany: New York State Office of Parks, Recreation and Historic Preservation; and Ithaca, NY, and London: Cornell University Press, 2013), 27 (illustrated 28, fig. 10). See also "Mountain Views and Coast Scenery, by a Landscape Painter," *Bulletin of the American Art-Union*, no. 8 (November 1850), 129–31, which was likely written by Church.

24. See Eleanor Jones Harvey, *The Painted Sketch* (Dallas: Dallas Museum of Art; New York: Harry N. Abrams, Inc., 1998), 219; Franklin Kelly, in Kevin Avery and Franklin Kelly, eds., *Hudson River School Visions: The Landscapes of Sanford R. Gifford* (New York: Metropolitan Museum of Art; New Haven and London: Yale University Press, 2003), 170, no. 39.

25. Sanford Robinson Gifford, *Bald Porcupine*, 1864, graphite on darkened off-white wove paper, 5½ × 8⅞ in. (13.9 × 22.5 cm), in Sketchbook: Mount Desert Island, Maine, Harvard Art Museums/Fogg Museum, Gift of Sanford Gifford, 2001.164.6.

26. Carr, *Frederic Edwin Church: Catalogue Raisonné*, vol. 1, no. 370, 229–230.

27. On the geological thinking ca. 1857 on the types of rocks and the issue of erosion at Niagara Falls, see *Proceedings of the American Association for the Advancement of Science* (Cambridge: Joseph Lovering; and New York: G. P. Putnam and Co., 1857), 77–78.

28. Gould, "Church, Humboldt, and Darwin," 97. See also Novak, *Nature and Culture*, 3rd ed., 59–70. The library at Olana houses five volumes of *Cosmos*, with publication dates ranging from 1849 to 1859, as listed in "Copy of Books in Church's Library at Olana," Olana State Historic Site. My thanks to Valerie Balint, formerly of Olana, for her assistance in obtaining this information.

SELECTED BIBLIOGRAPHY

ARCHIVAL SOURCES

Albany Institute of History and Art, McKinney
Library, Albany, NY:
 Erastus Dow Palmer Papers

Archives of American Art, Smithsonian
Institution, Washington, D.C.:
 Jasper Francis Cropsey Papers
 Asher B. Durand Papers
 Sanford Robinson Gifford Papers
 Thomas Moran Papers
 Worthington Whittredge Papers

The Archives of the Geological Society
of London

The Royal Institution of Great Britain,
London:
 Humphry Davy Papers

Olana State Historic Site, Hudson, NY

BOOKS, EXHIBITION CATALOGUES, ARTICLES, AND DISSERTATIONS

Anderson, Nancy K. *Thomas Moran*.
Washington, D.C.: National Gallery of Art;
New Haven and London: Yale University
Press, 1997.

Anderson, Nancy K., and Linda S. Ferber.
Albert Bierstadt: Art and Enterprise. Brooklyn,
NY: Brooklyn Museum; New York: Hudson
Hills Press, 1990.

Andrews, Malcolm. *Landscape and Western Art*.
New York: Oxford University Press, 1999.

Avery, Kevin J., and Franklin Kelly. *Hudson
River School Visions: The Landscapes of Sanford
R. Gifford*. New York: Metropolitan Museum
of Art; New Haven and London: Yale
University Press, 2003.

Barber, Lynn. *The Heyday of Natural History,
1820–1870*. New York: Doubleday and
Company, 1980.

Baur, John I. H., ed. *The Autobiography of
Worthington Whittredge 1820–1910*. New York:
Arno Press, 1969.

Bedell, Rebecca. "The History of the Earth:
Darwin, Geology and Landscape Art."
In *Endless Forms: Charles Darwin, Natural
Science and the Visual Arts*, ed. Diana Donald
and Jane Munro. Cambridge: Fitzwilliam
Museum; New Haven: Yale Center for
British Art, 2009, 48–79.

———. *The Anatomy of Nature: Geology and
American Landscape Painting, 1825–1875*.
Princeton and Oxford: Princeton University
Press, 2001.

———. "Thomas Cole and the Fashionable
Science." *Huntington Library Quarterly* 59, no.
2 and 3 (1996): 349–78.

Boime, Albert. *Art in an Age of Bonapartism
1800–1815*. Chicago and London: University
of Chicago Press, 1990.

Brownlee, Peter John, Valéria Piccoli, and
Georgiana Uhlyarik. *Picturing the Americas*.
New Haven and London: Yale University
Press, 2015.

Buckland, William. *Reliquiae Diluvianae*.
London: John Murray, 1824.

Busch, Werner. "Der Berg als Gegenstand von
Naturwissenschaft und Kunst, zu Goethes
geologischem Begriff." In *Goethe und die
Kunst*, edited by Sabine Schulze, 485–97.
Stuttgart: Hatje, 1994.

Carr, Gerald L. *Frederic Edwin Church: Catalogue
Raisonné of Works of Art at Olana State Historic
Site*. Cambridge: Cambridge University
Press, 1994.

Carus, Carl Gustav. *Nine Letters on Landscape
Painting, Written in the Years 1815–1824*. Los
Angeles: Getty Research Institute, 2002.

Caspar Wolf and the Aesthetic Conquest of Nature.
Basel: Kunstmuseum Basel, 2014.

Charlesworth, Michael. *Landscape and Vision
in Nineteenth-Century Britain and France*.
Aldershot, England; Burlington, VT:
Ashgate, 2008.

Charteris, Evan. *John Sargent*. New York:
Charles Scribner's Sons, 1927.

Cheetham, Mark. "Revision and Exploration:
German Landscape Depiction and Theory
in the Late Eighteenth Century," Ph.D.
diss., University of London, 1982.

Clarke, Michael, and Nicholas Penny, eds.
*The Arrogant Connoisseur: Richard Payne
Knight 1751–1824*. Manchester: Manchester
University Press, 1982.

Cloos, Hans. *Conversation with the Earth*. New
York: A. A. Knopf, 1953.

Colin, Nelly. "Jean-Claude Bonnefond et
l'Italie." In *Lyon et l'Italie: six études d'histoire
de l'art*, edited by Daniel Ternois, 213–35.
Paris: Éditions du Centre National de la
Recherche Scientifique, 1984.

Conisbee, Philip, Sarah Faunce, Jeremy
Strick, and Peter Galassi. *In the Light of Italy*.
Washington, D.C.: National Gallery of Art;
New Haven and London: Yale University
Press, 1996.

Cook, E. T., and Alexander Wedderburn, eds.
The Works of John Ruskin. London: George
Allen; New York: Longmans, Green, and
Co., 1903–12.

Cosgrove, Denis, and Stephen Daniels, eds.
The Iconography of Landscape. Cambridge:
Cambridge University Press, 1988.

Craig, G. Y., ed. *James Hutton's Theory of the
Earth: The Lost Drawings*. Edinburgh: Scottish
Academic Press, 1978.

Craven, Maxwell. *John Whitehurst of Derby:
Clockmaker and Scientist 1713–88*. Ashbourne,
Derbyshire: Mayfield Books, 1996.

The Crayon (New York, 1855–61).

Dean, Dennis R. "The Influence of Geology on
American Literature and Thought." In *Two
Hundred Years of Geology in America*, edited
by Cecil J. Schneer, 289–303. Hanover, NH:
University Press of New England, 1979.

DeLue, Rachael Z. "Humboldt's Picture
Theory." *American Art* 31, no. 2 (Summer
2017): 37–40.

Driscoll, John Paul, and John K. Howat. *John
Frederick Kensett*. Worcester, MA: Worcester
Art Museum; New York and London: W. W.
Norton and Company, 1985.

Egerton, J. E. "William Day 1764–1807." *Connoisseur* 174 (1970): 176–85.

Esper, Johann Friedrich. *Ausführliche Nachricht von neuentdeckten Zoolithen unbekannter vierfüsiger Thiere*. Nuremberg: Georg Wolfgang Knorrs Seel. Erben, 1774.

Evans, Joan, and John Howard Whitehouse, eds. *The Diaries of John Ruskin*. Oxford: Clarendon Press, 1956.

Ferber, Linda S. "William Trost Richards (1833–1905): American Landscape and Marine Painter." Ph.D. diss., Columbia University, 1980.

——, ed. *Kindred Spirits: Asher B. Durand and the American Landscape*. Brooklyn, NY: Brooklyn Museum; London: D. Giles Limited, 2007.

Ferber, Linda S., and William H. Gerdts. *The New Path*. Brooklyn, NY: Brooklyn Museum, 1985.

Feuchtmayr, Inge. *Johann Christian Reinhart 1761–1847*. Munich: Prestel Verlag, 1975.

Field Book Project. www.biovidlib.wikispaces.com.

Fraser, David. "'Fields of radiance': the Scientific and Industrial Scenes of Joseph Wright." In *The Iconography of Landscape*, edited by Denis Cosgrove and Stephen Daniels, 119–41. Cambridge: Cambridge University Press, 1988.

From View to Vision: British Watercolours from Sandby to Turner in the Whitworth Art Gallery. Manchester: Whitworth Art Gallery, 1993.

Gage, John. *J. M. W. Turner*. New Haven and London: Yale University Press, 1987.

Galassi, Peter. *Corot in Italy*. New Haven and London: Yale University Press, 1991.

Gamble, Cynthia. "John Ruskin, Eugène Viollet-le-Duc and the Alps." *Alpine Journal* 104 (1999): 185–96.

Gould, Stephen Jay. "Church, Humboldt, and Darwin: The Tension and Harmony of Art and Science." In *Frederic Edwin Church*, by Franklin Kelly, with Stephen Jay Gould, James Anthony Ryan, and Debora Rindge, 94–107. Washington, D.C.: National Gallery of Art, 1989.

Graciano, Andrew. "'The Book of Nature is Open to All Men': Geology, Mining, and History in Joseph Wright's Derbyshire Landscapes." *Huntington Library Quarterly* 68, no. 4 (2006): 83–99.

Grütter, Tina. *Melancholie und Abgrund*. Berlin: Dietrich Reimer Verlag, 1986.

Guntau, Martin. "The Rise of Geology as a Science in Germany around 1800." In *The Making of the Geological Society of London*, edited by C. L. E. Lewis and S. J. Knell, Geological Society Special Publication 317, 163–77. London: The Geological Society, 2009.

Gutwirth, Suzanne. "Jean-Charles-Joseph Rémond (1795–1875), Premier Grand Prix de Rome du Paysage historique." *Bulletin de la Société de l'Histoire de l'Art français* (1983): 189–218.

Hamilton, James. *Turner and the Scientists*. London: Tate Gallery Publishing, 1998.

Hamilton, Sir William. *Campi Phlegræi: Observations on the Volcanos of the Two Sicilies*. Naples, 1776.

Hargraves, Matthew. *Varieties of Romantic Experience*. New Haven: Yale Center for British Art, 2010.

Harvey, Eleanor Jones. *The Painted Sketch*. Dallas, TX: Dallas Museum of Art; New York: Harry N. Abrams, Inc., 1998.

Hauptman, William. *John Webber 1751–1793*. Bern and Manchester: Kunstmuseum Bern and Whitworth Art Gallery, University of Manchester, 1996.

Hausler, Bettina. "'Auf verdammt beschwerlichen Bergwegen': Carl Morgensterns Reisen in die Schweiz." In *Carl Morgenstern und die Landschaftsmalerei seiner Zeit*, 201–18. Frankfurt am Main: Museum Giersch, 2011.

——. *Der Berg: Schrecken und Faszination*. Munich: Hirmer Verlag, 2008.

Hawes, Louis. *Presences of Nature*. New Haven: Yale Center for British Art, 1982.

Heiken, Grant, ed. *Tuffs: Their Unique Properties, Uses, Hydrology, and Resources*, Special Paper 408. Boulder, CO: Geological Society of America, 2006.

Hendricks, Gordon. *Albert Bierstadt: Painter of the American West*. Fort Worth, TX: Amon Carter Museum of Western Art; New York: Harry N. Abrams, Inc., 1974.

Herdrich, Stephanie L., and H. Barbara Weinberg. *American Drawings and Watercolors in The Metropolitan Museum of Art: John Singer Sargent*. New York: Metropolitan Museum of Art, 2000.

Heringman, Noah. *Romantic Rocks, Aesthetic Geology*. Ithaca, NY: Cornell University Press, 2004.

Herrmann, Luke. *Nineteenth Century British Painting*. London: Giles de la Mare Publishers Limited, 2000.

Hewison, Robert, Ian Warrell and Stephen Wildman. *Ruskin, Turner and the Pre-Raphaelites*. London: Tate Gallery, 2000.

Hoopes, Donelson F. *The Düsseldorf Academy and the Americans*. Atlanta, GA: High Museum of Art, 1972.

Howat, John K. *Frederic Church*. New Haven and London: Yale University Press, 2005.

Humboldt, Alexander von. *Cosmos*. London: Henry G. Bohn, 1848–58.

——. *Views of the Cordilleras and Monuments of the Indigenous Peoples of the Americas*. Edited by Vera M. Kutzinski and Ottmar Ette. Chicago and London: University of Chicago Press, 2012.

Humboldt, Alexander von, and Aimé Bonpland. *Essay on the Geography of Plants*. Edited by Stephen T. Jackson. Chicago and London: University of Chicago Press, 2009.

Hutton, James. "Theory of the Earth: Or an Investigation of the Laws Observable in the Composition, Dissolution, and Restoration of Land upon the Globe." *Transactions of the Royal Society of Edinburgh* I (1788): 209–304, and plates.

——. *Theory of the Earth*. Edinburgh: printed for Messrs Cadell, junior, and Davies, London, and William Creech, Edinburgh, 1795.

Irwin, David, and Francina Irwin, eds. *Scottish Painters*. London: Faber and Faber, 1975.

Jenkins, Ian, and Kim Sloan. *Vases and Volcanoes: Sir William Hamilton and His Collection*. London: British Museum Press, 1996.

Johnston, Matthew N. *Narrating the Landscape: Print Culture and American Expansion in the Nineteenth Century*. Norman: University of Oklahoma, 2016.

Jones, Thomas. "Memoirs of Thomas Jones: Penkerrig Radnorshire." In *Walpole Society* 32 (1946–48): 1–143.

Kelly, Franklin, with Stephen Jay Gould, James Anthony Ryan, and Debora Rindge. *Frederic Edwin Church*. Washington, D.C.: National Gallery of Art, 1989.

Klonk, Charlotte. *Science and the Perception of Nature*. London: Paul Mellon Centre for Studies in British Art; New Haven and London: Yale University Press, 1996.

Kronick, David A. *A History of Scientific and Technical Periodicals*, 2nd ed. Metuchen, NJ: Scarecrow Press, 1976.

Lee, Paula Young. "'The Rational Point of View': Eugène-Emmanuel Viollet-le-Duc and the *Camera Lucida*." In *Landscapes of Memory and Experience*, edited by Jan Birksted, 63–76. New York and London: Spon Press, 2000.

Lewis, C. L. E., and S. J. Knell, eds. *The Making of the Geological Society of London*, Geological Society Special Publication 317. London: The Geological Society, 2009.

Lister, Raymond. *Catalogue Raisonné of the Works of Samuel Palmer*. Cambridge: Cambridge University Press, 1988.

——. *The Letters of Samuel Palmer*, vol. 1. Oxford: Clarendon Press, 1974.

Lowell Libson Limited. "Joseph Wright of Derby 1734–1797, *Mount Vesuvius*." In *Lowell Libson Ltd 2014*, 105–11. London: Lowell Libson, 2014.

Ludlow, Fitz Hugh. *The Heart of the Continent*. New York: Hurd and Houghton, 1870.

Lukacher, Brian. *Joseph Gandy*. New York: Thames and Hudson, 2006.

Lyell, Charles. *Life, Letters, and Journals of Sir Charles Lyell, Bart.*, edited by Mrs. (Katharine M.) Lyell. London: John Murray, 1881.

——. *Principles of Geology*. London: John Murray, 1830–33.

Mandevare, N. Al. Michel. *Principes raisonnés du paysage*. Paris: M. Boudeville, 1804.

Manthorne, Katherine. *Creation and Renewal*. Washington, D.C.: National Museum of American Art, Smithsonian Institution Press, 1985.

——. *Tropical Renaissance*. Washington, D.C.: Smithsonian Institution Press, 1989.

A Memorial Catalogue of the Paintings of Sanford Robinson Gifford, N.A. New York: Metropolitan Museum of Art, 1881.

Metcalf, Samuel L. "The Interest and Importance of Scientific Geology as a Subject for Study." *The Knickerbocker* 3, no. 4 (April 1834): 225–35.

Miller, Angela. *The Empire of the Eye: Landscape Representation and American Cultural Politics 1825–1875*. Ithaca, NY: Cornell University Press, 1993.

Miller, Douglas, ed. and trans. *Johann Wolfgang von Goethe: Scientific Studies*. New York: Suhrkamp Publishers, 1988.

Miller, Hugh. *Landscape Geology: A Plea for the Study of Geology by Landscape Painters*. Edinburgh and London: William Blackwood and Sons, 1891.

——. *The Old Red Sandstone; or New Walks in an Old Field*, 2nd ed. Edinburgh: John Johnstone; and London: R. Groombridge, 1842.

Mitchell, Timothy F. *Art and Science in German Landscape Painting, 1770–1840*. Oxford: Clarendon Press, 1993.

——. "Caspar Friedrich's *Der Watzmann*: German Romantic Painting and Historical Geology." *Art Bulletin* 66, no. 3 (1984): 452–64.

Morand, Anne. *Thomas Moran: The Field Sketches, 1856–1923*. Norman and London: University of Oklahoma Press; Tulsa: Thomas Gilcrease Institute of American History and Art, 1996.

Newall, Christopher, ed. *John Ruskin: Artist and Observer*. Ottawa: National Gallery of Canada; Edinburgh: National Gallery of Scotland, 2014.

Nicolson, Benedict. *Joseph Wright of Derby*. London: Paul Mellon Foundation for British Art; New York: Pantheon Books, 1968.

Nordhoff, Claudia. "Jakob Philipp Hackert. Leben und Werk." In *Jakob Philipp Hackert: Europas Landschaftsmaler der Goethezeit*. Hamburg: Hamburger Kunsthalle; Weimar: Klassic Stiftung Weimar, 2008.

Novak, Barbara. *Nature and Culture: American Landscape and Painting 1825–1875*, 3rd ed. New York and Oxford: Oxford University Press, 2007.

N. P. C. "Relation between Geology and Landscape Painting." *The Crayon* (August 1859): 255–56.

O'Connor, Ralph. *The Earth on Show*. Chicago and London: University of Chicago Press, 2007.

——. "Facts and Fancies: the Geological Society of London and the Wider Public, 1807–1837." In *The Making of the Geological Society of London*, edited by C. L. E. Lewis and S. J. Knell, Geological Society Special Publication 317, 331–40. London: The Geological Society, 2009.

Osborne, Carol M. *William Trost Richards: True to Nature*. Stanford, CA: Iris and B. Gerald Cantor Center for Visual Arts at Stanford University; London: Philip Wilson Publishers, 2010.

Oxford Dictionary of National Biography, www.oxforddnb.com.

Page, David. *Chips and Chapters*. Edinburgh and London: William Blackwood and Sons, 1869.

Paris, John Ayrton. *The Life of Sir Humphry Davy, Bart. LL.D.*. vol. 1. London: Henry Colburn and Richard Bentley, 1831.

Parry, III, Ellwood C. *The Art of Thomas Cole*. Newark: University of Delaware Press; London and Toronto: Associated University Presses, 1988.

Payne, Christiana. *John Brett, Pre-Raphaelite Landscape Painter*. New Haven and London: Yale University Press for the Paul Mellon Centre for Studies in British Art, 2010.

Paysages d'Italie: Les peintres du plein air, 1780–1830. Paris: Réunion des musées nationaux, 2001.

Pointon, Marcia. "Geology and Landscape Painting in Nineteenth-Century England." In *Images of the Earth*, ed. Ludmilla Jordanova and Roy S. Porter, 84–108. Chalfont St. Giles, Bucks.: British Society for the History of Science, 1979.

Porter, Roy. *The Making of Geology: Earth Science in Britain 1660–1815*. Cambridge: Cambridge University Press, 1977.

Raab, Jennifer. *Frederic Church*. New Haven and London: Yale University Press, 2015.

Raeber, Willi. *Caspar Wolf*. Aarau, Frankfurt am Main, Salzburg: Sauerländer; Munich: Prestel, 1979.

Rappaport, Rhoda. *When Geologists Were Historians, 1665–1750*. Ithaca, NY: Cornell University Press, 1997.

Reed, Michael. *The Landscape of Britain: From the Beginnings to 1914*. Savage, MD: Barnes and Noble Books, 1990.

Rosenberg, Gary D., ed. *The Revolution in Geology from the Renaissance to the Enlightenment*, Geological Society of America Memoirs 203. Boulder, CO: Geological Society of America, 2009, 13–40.

Rothenberg, Marc. *The History of Science in the United States*. New York and London: Garland Publishing, Inc., 2001.

Rubin, Stephen D. *John Singer Sargent's Alpine Sketchbooks*. New York: Metropolitan Museum of Art, 1991.

Rudwick, Martin J. S. *Bursting the Limits of Time: The Reconstruction of Geohistory in the Age of Revolution*. Chicago and London: University of Chicago Press, 2005.

——. "The Early Geological Society of London in Its International Context." In *The Making of the Geological Society of London*, edited by C. L. E. Lewis and S. J. Knell, Geological Society Special Publication 317, 145–53. London: The Geological Society, 2009.

——. "The Emergence of a Visual Language for Geological Science, 1760–1840." *History of Science* 14, no. 3 (1976): 149–95.

——. *The Great Devonian Controversy*. Chicago and London: University of Chicago Press, 1985.

——. Review of *James Hutton's Theory of the Earth: The Lost Drawings*, by G. Y. Craig, D. B. McIntyre, and C. D. Waterson. *British Journal for the History of Science* 13, no. 1 (March 1980): 82–83.

——. *The New Science of Geology*. Aldershot, Hampshire, and Burlington, VT: Ashgate, 2004.

Rupke, Nicolaas A. *The Great Chain of History: William Buckland and the English School of Geology (1814–1849)*. Oxford: Clarendon Press; New York: Oxford University Press, 1983.

Ruskin, John. *Deucalion and Other Studies in Rocks and Stones*. London: George Allen, 1906.

——. *Early Prose Writings 1834 to 1843*. London: George Allen; New York: Longmans, Green, and Co., 1903.

——. *Modern Painters*. 5 vols. London: Smith, Elder, and Co., 1843–60.

——. *Pre-Raphaelitism*. New York: Wiley, 1851.

Schmid, F. Carlo. *Johann Christian Reinhart: Ein deutscher Landschaftsmaler in Rom*. Munich: Hirmer, 2012.

Schulze, Sabine, ed. *Goethe und die Kunst*. Stuttgart: Hatje, 1994.

Secord, James A. *Controversy in Victorian Geology*. Princeton: Princeton University Press, 1986.

Siegfried, Robert, and R. H. Dott, Jr. "Humphry Davy as Geologist, 1805–29." *British Journal for the History of Science* 9, no. 2 (July 1976): 219–27.

Sloan, Kim. *Alexander and John Robert Cozens: The Poetry of Landscape*. New Haven and London: Yale University Press; published in association with the Art Gallery of Ontario, 1986.

Spanagel, David I. *DeWitt Clinton and Amos Eaton*. Baltimore: Johns Hopkins University Press, 2014.

Stafford, Barbara Maria. *Voyage into Substance: Art, Science, Nature, and the Illustrated Travel Account, 1760–1840*. Cambridge, MA, and London: MIT Press, 1984.

Staley, Allen. *The Pre-Raphaelite Landscape*, 2nd ed. New Haven: Yale University Press, 2001.

Staley, Allen, and Christopher Newall. *Pre-Raphaelite Vision: Truth to Nature*. London: Tate Publishing, 2004.

Stebbins Jr., Theodore E. *The Lure of Italy*. Boston: Museum of Fine Arts, 1992.

Sumner, Ann, and Greg Smith, eds. *Thomas Jones*. New Haven and London: Yale University Press, in association with National Museums and Galleries of Wales, 2003.

Talbot, William S. *Jasper F. Cropsey, 1823–1900*. Ph.D. diss., Institute of Fine Arts, New York University, 1972.

Taquet, Philippe. "Geology beyond the Channel: the Beginnings of Geohistory in Early Nineteenth-Century France." In *The Making of the Geological Society of London*, edited by C. L. E. Lewis and S. J. Knell, Geological Society Special Publication 317, 155–62. London: The Geological Society, 2009.

Thackray, John. "'The Modern Pliny': Hamilton and Vesuvius." In *Vases and Volcanoes: Sir William Hamilton and His Collection*, edited by Ian Jenkins and Kim Sloan, 65–74. London: British Museum Press, 1996.

The Thaw Collection of Master Drawings: Acquisitions Since 2002. New York: Morgan Library and Museum, 2009.

Tonkovich, Jennifer, comp. *Studying Nature: Oil Sketches from the Thaw Collection*. New York: Morgan Library and Museum, 2011.

Trump, Richard Shafer. "Life and Works of Albert Bierstadt," Ph.D. diss., Ohio State University, Columbus, 1963.

Tuckerman, Henry T. *Book of the Artists: American Artist Life*. New York: G. P. Putnam & Son, 1867.

Uglow, Jenny. *The Lunar Men: Five Friends Whose Curiosity Changed the World*. New York: Farrar, Straus and Giroux, 2002.

Unity of Nature: Alexander von Humboldt and the Americas. New York: Americas Society; Bielefeld: Kerber Verlag, 2014.

Vai, Gian Battista. "Light and Shadow: The Status of Italian Geology Around 1807." In *The Making of the Geological Society of London*, edited by C. L. E. Lewis and S. J. Knell, Geological Society Special Publication 317, 179–202. London: The Geological Society, 2009.

Valenciennes, P. H. *Élémens de perspective pratique*. Paris: The Author, Desenne, and Duprat, 1800.

Vedder, Lee A., with contributions by Kerry Dean Carso and David Schuyler. *Jervis McEntee*. New Paltz, NY: Samuel Dorsky Museum of Art, 2015.

Viollet-le-Duc, E. *Le Massif du Mont Blanc*. Paris: Librairie Polytechnique, 1876.

Walford, Thomas. *The Scientific Tourist Through England, Wales, and Scotland*. London: J. Booth, 1818.

Walton, Paul H. *The Drawings of John Ruskin*. Oxford: Clarendon Press, 1972.

Weiss, Ila. "Sanford Robinson Gifford (1823–1880)," Ph.D. diss., Columbia University, 1968.

Whitehurst, John. *Inquiry into the Original State and Formation of the Earth*. London: Printed for the author, and W. Bent, by J. Cooper, 1778.

Wilmerding, John. *The Artist's Mount Desert: American Painters on the Maine Coast*. Princeton: Princeton University Press, 1994.

——. *Maine Sublime*. Hudson, NY: Olana Partnership; Albany: New York State Office of Parks, Recreation and Historic Preservation; Ithaca, NY and London: Cornell University Press, 2012.

Wilson, Leonard G. *Charles Lyell*. New Haven and London: Yale University Press, 1972.

Wilton, Andrew. *The Art of Alexander and John Robert Cozens*. New Haven: Yale Center for British Art, 1980.

——. *Frederic Church and the Landscape Oil Sketch*. London: National Gallery Company, 2013.

——. *J. M. W. Turner: His Art and Life*. Secaucus, NJ: Poplar Books, 1979.

——. "Personal View: Turner at Brunnen." *Turner Studies* 1, no. 2 (Winter 1981): 63–64.

Wilton, Andrew, and Tim Barringer. *American Sublime*. Princeton: Princeton University Press, 2002.

INDEX